Holding The Bruised Rose Blossoms Of An Attempted Genetic Rinse

Thomas L. Goss

For Angela, my eternal muse.

a primer on how to mislead the stars

take 1 part dessicated heart petals,
stained with blood of human yearning

mix with 2 parts fossilized true love

shake for half as long as all the times
you've wept Things into words

then swallow

I. Under The Eaves Of The Forested Glen

Location: Butterfly Tattoo

I.
All that we have crushed out of nature
by the flood of concrete
and glass-metal-brick buildings

is reborn in you.

II.
I am
vulnerable to your tenderness
yet
my surrounding arms
are strengthened by
our root-muscled love.

III.
A clock ticks and
its mechanical hand
is merely a gesture
of reverence
in anticipation
of the next moment
with you.

IV.
Necessity of the strands
of hair bisecting
the harmony-drenched curve
of your face:

again I close my eyes
and fall.

Home

The winter flower's bloom
erupts in fragrance
as your weariness cascades
and crumbles with each step closer
to the warmth of home
(which is simply any space
in the universe where
our hands meet
and our eyes say hello).

In truth,
I hold on to you tightest
in the moments
when we close ourselves off
from one another.

Even during floods of anger
I know that soon,
in the patient darkness,
only regenerating beauty
will spill from your night-sleeping eyes
to mine.

You Photograph Flowers, Naked Masses of Protoplasm

Fragrant fields
invoke your opening shutter:
you build stamens into white resonance.

With the tilt of the lens
you hold back your breath
to halt the photo-blur.

The army of slime mold cells below
silently begins its glacial escape
as your mouth softens in anticipation
of capturing a pristine moment.

The scattered forest tops
shade your eyebrows
with the vertical upheaval
of decades-young canopy.

Can you see? In the clock-stop
stillness of a camera's blinking eye
you tighten your grip on yourself
while still kneeling lightly
on the floors of nature.

Thus you open places that appear
all at once before you,
and culminate in the narrow beak of a winter bird
that rests momentarily on your shovel
before gratefully returning
to the archeological dig near your feet,
where it exhumes, then eats,
its breakfast of worms.

Kiss Revelation

Tempted by the elliptical curls of your distinct red hair,
I am flooded by your stream-smooth reality
yet still I float calmly to your swaying surface
to meet your lips.

In the silence of your closed eyes
I hear the soft trail of your searching steps
echo silently against the vibrant, wind beaten landscape,
and I smile because I know:
when the translucent wings of the dragonfly
pause against a contrasting flower top
and he turns his brilliant oval eyes toward you -
you become the sky.

Fairy Eyes Bloom Into Quiet Shelter

1.
The dense feminine weeping threatens to disappear
into black forest stones carpeted with lichen.

I step closer, in search of the source of pain.

Instead, I am confronted by
a voracious wall of writhing foliage:
a seedling tower of protection.

2.
Constructed with butterfly legs,
grafted against her mossy thoughts
in confused spasms,
it seemed to invoke *itself*
as my feet dumbly rustled leaves.

3.
I froze like a spider's victim
as I watched her fertile buzzsaw tears
tear open slits of green pillow,
exposing the gangly thickets of discontent
that must have tied her sleeping subconscious
into taunting ovals.

4.
Ah, those soul-staggering eyes.

Dense wildwood-night concussions
cascaded from her diamond-tipped gaze to mine,
sharpening the dullest corners of my head
until suddenly I felt the eruption of newly curious
fingertips, eyes, and knees.

She watched in mischievous fascination
as I spelled out in a hundred blades of picked grass
the youthful and mute vocabulary
of *adulthood lost* and *childhood regained*.

The Kiss Of Twilight, The Shape Of Your Face

I.
As we tenderly bathe in the promenading half-light,
the sun's dwindling momentum seeps into the relaxing waters
that softly stream from our sleek-eyed caresses.

Smoothly the life-giving rays of the sunset
fold the day into twisting shadows
that slither across the gnarled,
petrified feet of the ancient trees.

As our fevered bodies press against
the boundaries of the daylight's edge,
we playfully surf the mirror-like reflections
that flow from our gently glowing eyes.

II.
Before I stumbled into this joy-littered terrain
the spiraling dust trail behind my pale steps
would stretch for miles,
disappearing into smoky nothingness.

Like a dragon's nostrils at dawn
each new day oozed an obscuring mist,
forcing me into a tentative crouch
as I sluggishly crawled over the swaying rope bridges
of my wandering heart-center.

III.
Eventually these exquisite and volatile echoes
of fiery love-collision may pierce and drain
this glistening lake-on-a-mountaintop,
flooding our sparkling waters of passionate companionship
into the fertile valleys below,
into the fertile valleys below.

IV.
But for now,
as the visible light of the sun-bleached hillside retreats:
we revel in the galloping dark's encroaching oasis.

Articulated by Raising the Blade of the Tongue

1.
Nervous butterflies line my palms with coronal patterns:
silent, colorful eyes that erupt with the crunch and
scald of evolution.

2.
I set a trap of future lullabies and pet names
under your patiently restrained eyes
(which twitch and pause with the muscled power
of romantic possibility).

3.
The wisping curtain of our harmoniously whispered song
flows from the stringed instrument of our meeting eyelashes
and penetrates our concrete-carved defenses
with the sun-kissed beauty of our outstretched,
welcoming palms.

The Mechanics of Our Lips

Repeating heart-thought of your frictionless kiss
and the shy graveyard there (written upon your ripening lower lip) -
how surpassingly tender our slightly upward movement feels
as our proximity-magnified faces meet.

How the blossoms from your irises laugh at the ghost headstones
that must form in the fluency of our saliva:
senseless words about others
and their weightless gravity-crunch endings.

Lip-meeting after lip-meeting we fuse-bloom together;
at last freeing the ancient genomes
so explicit in the steady wrinkles of our foreheads,
and in the meandering curvature of our chins.

The Inertia Of Your Eyes Speaks Of Ultraviolet Radiation

When the gleaming sunlight
highlights in adventurous
and devoted brush-strokes
the striking terrain of your forceful,
regal face

my paralyzed body-movement
drops a galaxy-sized anchor
carved with the poignant instruments
of innocence and
boundless admiration.

I am rapturously plunged
inside your forceful dark-amber gaze,
left awestruck by your familiar ocean depths:
with a swarming, sublime resonance
you transform me into a venerable
and hardy tree whose sustenance flows
ever downward from the undecayed summit
of our flourishing love-accumulation.

An Introduction To Fairy-String Theory

1.
In the midst of the unrelenting
and implacable ocean waves of life
I've made the molecular heart-docking calculations
that prove our subatomic kisses
were forged and dispersed
from the harsh center
of every radioactive star.

2.
The unmeasurable nanoseconds
when your lips thrust towards mine:
it is then that I transform into your quantum-gravitational slave,
spinning helplessly in moon-like pirouettes
like a fawning Janus,
blissfully content to orbit
the tender brilliance
of Saturn's rings.

3.
My eyes glow with electromagnetic fervor
as you plant me into the regenerative soil
of this face-to-face embrace.

Our bodies unite in supersymmetry
as your artful emerald fingers
tend this love-garden into abundance.

With moves reminiscent of a graceful ballet,
the delicate and fruitful interplay
between your consciousness and mine
weaves each of our many weaknesses
into a geometrically precise canvas of strength.

4.
Every day your tongue ties the
cherry stems of my heart
into a tsunami of Origami-like creations,
each of which rises awkwardly skyward
on prismatic paper wings that joyfully scintillate
in the humbled rays of the illuminating sun.

With A Painter's Confident Swoop She Remade The Sky

I tremble towards you slowly,
tripping into shuddering branches
as uncertainty whips heavy circles of anticipation
into my clay-stained palms.

I pluck a ripe tomb
from your moonlit eyes
and fill it with flitting sparrow shadows,
each one fiercely whittled
from the over-burned stack
of heart-wood lodged in my throat.

Your thirsty stare encircles me
one poignant caterpillar spike at a time;
borrowing the sticky twilight-geometry of spider silk,
you meticulously reinforce the splintered trunk
of my heart.

Of moving on
we know nothing.

As our ambrosial kisses stammer in particles and waves
they ignite into a necklace of slumbering lotus seeds:
thousand-year memories of human regression and procession
that churn like mammoth wheels,
revealing the steady clock-like drift
of our intertwined subconscious minds
which sprint effortlessly back and forth
between the rival kingdoms of Hunger and Satiety.

It seems we'll always have mouths
for filling, won't we?

This parallel, brain-spun revival,
this billion spider journey
of silk tunnels still encases me
knuckle to knuckle,
until finally the sun-fed proclamation
of your alluring fingers unravels
each skin-thin strand with inhuman speed
and sublime accuracy.

Freedom streams into me fitfully
and I smile with curious awe
as stark geometric diagrams
plot the dazzling convolutions
of your garden-dancing hips.

We covet the moist essence
of our volcano-melted edges
until the segmented worms of possibility
digest the sky into swirling puddles
of florid fever-dreams that
we escape only by rebuilding
our destabilized molecules one by one
in the accelerated consciousness
of our enjoined lips.

II. Feast Upon Her Hips, For She Is Magnified In Dreams

The Molten Landmark Of Her Smile

1.
Chased from every upturned mountain of the past
the erotic curvature of her lower back consolidates
epochs of time into a single earthshaking kiss.

As our lips part
we luxuriously dissolve
like dense flakes of gold
into the river of nectar
that stretches across the blossoming geography
of our exploring fingertips.

2.
Oh,
the body
of a woman

the weight
of a thumping heart

the crispness of this desire
like scent of rain, of Cedar, of Lilac.

Love Is A Lighthouse Buttressing The Red-Shifted Skies

Anchored by the immediacy of our first kiss
we weave cascading threads of hope in perfect sequence
into the dome-like structure of our rapidly expanding hearts.

Though our carbon-lined consciousness
seems to disappear each night into the achromatic sky,
whenever we are simultaneously cradled by sleep
we share an aurora of florid love-light
which patiently shimmers behind our closed eyelids,
revealing to the careful observer that
even when our minds must drift apart:
our mirrored faces of joy still remain.

Eyes That Capture The Rainbow's End

I.
Even in the vacuum of space
nothingness does not exist:
ubiquitous quantum bubbles
fizzle in and out of existence
with an unimaginably small effervescence
that sleeps like a whisper on the tip
of every sentient tongue.

Yet here on Earth
she twitches her legs like a relaxed tigress,
clawing the warped edges of her sensual silhouette
into my anxious periphery with the molten buoyancy
of an underwater volcano.

II.
Whenever our waterfalls of consciousness collide
I softly wince as my over-matched heartbeats float by,
thumping a steady rhythm of surrender
into these heart-soaked edges of breathlessness.

In This Reverie She Wears A Saturn-Like Halo

I.
My heart drops like an anvil into a dream-like state,
sliding heavily downward towards a floor of velvet enslavement;
I become a servant to your gaze,
and the world-swirling curves of your inner thighs.

As shimmering rows of hushed surrender
blossom from my lips onto the suppleness of your stomach,
my essence emerges in rhythm with the hypnotic waves of seduction.

II.
Oh,
to slip breathlessly inside,
shuddering as the earth quakes:
is this not an awakening?

To stumble joyfully down this mountain of belonging
as these tumbling boulders of consciousness
disperse into drunken star shine!

Is this not an exorcism of desire?

III.
Yet soon we race past the tall,
soft grasses of the valley of fulfillment,
diving recklessly once more into this river of delight,
where we rise above the currents
on the buoyancy of our blissful hearts,
where we both belong,
where we both belong.

Obliterated By The Diamond Minefield Of Our Love

I.
Whenever the blade of emotion
shreds these curtains of self,
she sees the dilapidated searchlight
that prowls the cobweb-covered corridors
of my vulnerable heart.

If I tumble again into
the sapphire waterfall of anger,
let the virulent chains of thought
disintegrate quickly into the day's sky
like a smoky flag of coal butterflies.

II.
Later she binds our hands like twigs,
resuscitates the full boil of our love
with the effervescent motion of her stealthy fingertips
(which gently ghost-walk over my joy-lined palms).

Our bodies flutter
like windswept bonfires
as we hungrily stalk pleasure's arrow.

Smoke signals slither upwards,
creating translucent trees
that gently rise above the horizon.

As our time-lines slowly synchronize
we relentlessly melt into the flickering shadows
of our candlelit canyon of joy.

III.
I am stranded
inside your universe-stomping
oasis of sensuality,
ever awaiting the warmth of your parted sea,
the taste of your salt.

Born To Promenade Into The Stonewashed Abyss

I.
She inhabits
her dresses and dreams
close to the surface
like satin sleeves.

She sometimes speaks of suicide
but suspects she will remain
vibrant and oxygenated and alive.

In the magnified moment before she cries
glistening drops of amber perception
rain down from the warped evening sky.

As she submerges and sinks
into the swirling current of her mushrooming discontent
she strangles the gentle sputter of teardrops
just to capture the way the world's scorched reflection
rises like heat from the desert of her eyes.

II.
As she unlocks the delicately ornamented
entrance to our beautifying love-kingdom
the precious metals of the gate and key
melt together into a cresting wave of molten desire.

Oh the sultry saunter
of a stalking heart,
the blissful premonition
of her luscious lips and
storm-calming face leaning in
to tend our garden of kisses.

As the mirror's flowery countenance
flashes bits of bare skin in delightful fits,
a pinkish aura playfully prances
along the sensual line
of her buttoned up belly
before finally trickling down my optic nerves,
to send my heart stumbling.

III.
She says
together we
bulldoze her tears.

Together we surprise
like rows of war dead
reborn as ancient trees.

Together we rise nearer to the sun:
straining to reach the star-scraped skies
yet content to rearrange the legion wavelengths of light
into soothing bouquets that burst in colorful spurts
against the mile-high roots of our love.

IV.
*She inhabits
her dresses and dreams
close to the surface
like satin sleeves.*

Love-Singularity (Awakened By The Tectonic Forces Of Delirium)

I.
Sensuality orbits inside her irises
like a rising river of lightning;
I long for her flickering hands
to carve shadows into my skin.

As our bodies drift closer,
the tremendous crackle of our electric love potential
streaks past our assembling thought bridges
like a flock of neon swans.

She intently studies my face,
unleashing a tsunami of desire.

Visions of a dress-less,
breathless her leap like a pack of dolphins
from my ravenous eyes:
repeatedly breaching
the thin boundary that
separates sea and sky.

As the thunderous wave of yearning
pulses steadily through me,
the blackened stone of my crumbling heart-fortress
dreamily dissolves like sandcastle walls.

I am left exposed,
a pebble in its cavernous wake.

II.
As the mesmerizing swans of desire regroup and return
I am brought to my knees like a worshiping peasant.

My heart helplessly trails the trajectory
of the encircling birds as they rain down
flurry after flurry of silk from their knitting wingtips,
transforming my crouching form into a statuesque cocoon
of quicksilver anticipation.

I slip from gravity's grip
like a thousand separate strands
of her strawberry hair,
blowing in the wind.

I am carried upon the dawn's horizon
like a giant caterpillar,
hurled too soon into the sapphire sky.

I melt into the pillowy clouds
like a tired child cradled in the arms of mother:
straining to remain aware
yet content to float idly by,
one finger slicing a trail of ripples
into the deepening river of imagination,
two ears gently catching the intensifying rush of water
as it escapes skyward from the vast ocean trenches of dreams.

III.
Before my freshly unbound eyes
can adjust to the crisp mountain air
my heart cascades like a barrel
over the scintillating waterfall
of her receptive smile.

As I splash down
the tumultuous bats of excitement
scatter like light through a prism,
coating her beguiling eyes
with the water-born hues
of passionate escape.

With a playful wink of her eye
the cocoon's unwinding accelerates.

At first the strands simply snake
into the ground and disappear,
but soon enormous caterpillars of shimmering silk
emerge to form an enduring tree of joy.

Here underneath its expansive boughs
our fluctuating heart-leaps synchronize.

As we bathe in the universe's greatest bounty,
our eyelashes collide like gilded butterflies.

IV.
Without these hungry fingertips
how could I sketch the capricious curves
of her blossoming body-language?

Without this dexterous tongue
how could I taste the kaleidoscopic streaks
that so sweetly stain the emotional foothills of our love?

The Echo Collector Awakens Alone

I.
Beckoned by the lopsided geometry of a half-empty bed
the vine-entangled walls of my imagination crumble like leaves
into the concrete waters of the present.

As awareness detonates
a rioting hailstorm of consciousness
hammers heart-echoes in rapidly diminishing waves
against the concave shores of my charred psyche.

Dawn's crisp light crawls
over the roundness of my lips,
melting moonlit memories
into teardrops that fall like icicles
from the ovals in my face.

Dipping her toes
into my fragile lake of thought,
she created a plaster cast
of the footsteps of time.

II.
Though the rigid tremors of *Now*
threaten to crumble the wobbling edifice of our past,
still we float together on this nostalgic life raft,
sharing air and space and memory.

Even as regret seeps
like a psychedelic river of graffiti
from our time-weary heartbeats:
still nothing is destroyed.

This solitary mountain trail
winds into the eastern sun,
yet as my sprinting feet strike the Earth
I cannot escape the panoramic view
of the towering marble columns we erected
while drunk on love's astonishing elixir.

Cocooned inside the irrepressible buoyancy
of a raging bonfire our hearts leapt skyward:
there she dipped her fingertips into the drifting clouds,
massaging a miniature portrait of the sky
onto the subtle canvas of my eyes.

Knifing Through The Atmosphere, Two Intertwined Eagles Are Reborn As Clouds

I.
Like a rising tsunami of ravenous butterflies,
frantic wavelengths of light rebound
from your eyes to mine.

The deafening hush of delicate wingspots
buries my vision in a flamboyant coffin of fluctuating color-burst
as I dip and sway, dip and sway.

Yet abruptly their riotous hues scatter skyward,
leaving only your sublimely expressive countenance
chiseled into the dawning canyon of my mind,
chiseled into the dawning canyon of my mind.

II.
As the intensifying arc of our electric love potential
prepares to quantum jump the vast distance
that separates our still-apprehensive hearts:
I reach for your hand.

Like a star's fusing center
we powerfully dissolve into sunspots
as our fingers unite in electromagnetic glee.

Our future and past blur together
like combined singularities.

As we begin to share skin
we swallow matter and freeze time,
draining the entire cauldron of the universe
with the superstraw of our love.

III.
Just when we thought
we had vanquished the universe
the prismatic explosion of ordinary life
and its self-assembling molecules
swiftly reasserts itself into our vision.

How startling it is
to become distinct again,
planet-bound again,
chained to the Earth
and its ever-resilient cycle
of mutation and rebirth,
mutation and rebirth.

And how we covet those moments
when physics hands the reigns to Love,
allowing us to wander unbound
as both particle and wave,
sunset and sunrise,
beginning and end.

How startling it is
to become distinct again,
planet-bound again,
chained to the Earth
and its ever-resilient cycle
of mutation and rebirth,
mutation and rebirth.

IV.
Though the separation of our bodies remains,
our trajectories still slowly spiral closer in adoration,
delighted to be caught in each other's orbit,
patiently awaiting the next moment
when we'll leave the planets behind:
blasting off into the unsurpassed geometry
of our otherworldly embrace.

III. The Cosmological, Constant

Volcanism Of The Heart

I.
Tonight the moon coasts by
like an iron firefly,
disappearing for heavy moments
then suddenly arising on fluttering wings
as our eyes again tumble skyward.

Tonight we anchor the moon to the earth
as we drown in the molten core
of each other's eyes.

Here,
bathed in ancient starlight,
we surrender.

II.
Tonight we erupt
in the soft darkness of awareness
that glows momentarily
in this sustained stillness
like a bowstring drawn taut,
with the arrow of time resting
upon the quiver.

Tonight we anchor the moon to the earth
as we drown in the molten core
of each other's eyes.

Here,
bathed in ancient starlight,
we surrender.

Rising From The Depths Of This Magnificent Tomb, We Face The Sky

I.
Kiss me here
under the azure skies
where time kills.

Kiss me here
where the mind's eye
simmers in fear.

Taste me tonight
where once again
the trickster's balm
of artistic expression
has failed to soothe
my aching eyes.

Even in the tomb
of King Mausolus
there is no rest,
for words do not heal,
they merely reflect the torrid currents
that flow through the twin rivers of sight.

Words,
even those etched in stone,
merely reflect.

So take me into blackest night:
above the embers impale me
with the funeral-scarred skies
as I tenderly genuflect.

II.
Starry sky,
you compass
of my forlorn heart,
your ubiquitous light-streams
only heighten the rush
of the precisely-calibrated oxygen
that courses through my brain.

Words,
even those etched in stone,
merely reflect.

So take me into blackest night:
above the embers impale me
with the funeral-scarred skies
as I tenderly genuflect.

III.
Desire,
your sharpened mountain peaks
can never overflow enough
to float this wretched boat,
so I disown you,
again and again,
again and again.

Oh,
to survive this time-quake,
to scale this tremendously blackened monument
is a testament to the wiry limbs of life:
from my vantage point here in the teeming silence,
how the galaxies swirl, how the galaxies swirl!

I feel the screams of contemplation
as their wounds of dislocation
erupt from a billion distant points,
cascading in front of my eyes like falling stars:
the light years streak onto the canvas
in carefully-measured caresses,
carefully-measured caresses.

IV.
Tethered to this fragile satellite,
the mind feels like a universe-sized wormhole,
a supernova bloom that engulfs
the event horizon of a black hole.

Oh, the bitter give-and-take,
the bitter give-and-take:
even the handful of light years
that separates us from the nearest star is
a meager teardrop thoughtfully descending
into the cloaked cauldron of time.

V.
So taste me tonight
where once again
the trickster's balm
has failed to soothe
my aching eyes.

Kiss me here
in the twilight
where the mind's eye
simmers in fear.

Kiss me here
under the azure skies
where time kills.

As Prismatic Memories Dissolve, Space-Time Accelerates

I.
The parallel lines of her specter-like eyes
rise from the misty spires of the past
like two spikes in a spectrograph.

As the mind sails through three dimensional space
time's boomerang batters its latest victim
with faint tendrils of yearning.

II.
Never-say-goodbye memories
are left stranded on salty islands of velvet,
ever awaiting the devouring tongue,
ever awaiting the hungry singularities of separation
that feast like fungi upon splintered memories.

If matter obediently circles
like water down a drain,
then love lost grips like the gnarled arms
of five-thousand-year old trees,
strangling.

III.
Whistling to overcome the hum of decay
we recklessly ascend burnt treetops
while trying to ensnare and topple
the night moon's sunlit face.

Yet our heart-shaped clouds
of enslaved matter always
slide helplessly into the event horizon.

And even the atoms in a kiss never really touch,
but are simply squashed against the writhing boundaries
of two parallel magnetic fields.

IV.
Deep within the swirling eyes of Jupiter
broken rainbows of epiphany disintegrate
into scintillating droplets of helium- and neon-laced rain.

A Slave To This Slaughterhouse Imagination

I.
Sharp tree-fingers of sun shadow
creep steadily across the forest floor.

Bare feet stumble hastily over nature's
haphazard patchwork: a stitched together
blanket of bruised autumn leaves.

Trembling toes grip the frozen soil
as stinging eyes wander delicately over
the contours of an ice-coated river.

Overhead the mangled vines creak,
the canopy a tortured swirl of limbs
and snakes that the taunting trees
have sewn together in a writhing knot
of entropic defiance.

As the perspective shifts
the brooding sky above
shrinks into a pale blue dot,
only held into place by the sun's
wistful nuclear exhalations.

II.
Pale rope-like fingers
weave through a slipknot mind,
coaxing forth reptilian skin
which sporadically flares in angry hues
like a sputtering eternal flame:
fitfully oxidizing methane
from the earth below.

Dreams burrow like icicles into
the oval windows of consciousness.

Rise to the top.
Rise to the top of the swelling anger,
surf the bleeding waves of retribution.

The artist must aim their only weapon
towards the universe's hungry heel
(forever staining the dark cosmos
with splashes of righteous indignation).

III.
The smell of burnt velvet rises
from the soft blue flames
of limping courtship.

The hallmark vibrations of the universe
guide our drunken rhythms step by step,
eventually leading to the intoxicating movements
that distinguish this brutal dance of the living.

Oh, the brittle brilliance of a mind
held up on chopstick stilts,
of a mind that reaches deeply
into the sea of writhing photons
only to pull out the wistful
sound of entropy laughing.

IV.
Pale rope-like fingers
weave through a slipknot mind,
leaving the tattered cloth of resentment
hanging down in battered strands.

These are the staggering heart wounds
of consciousness, displayed for all to see.

Dreams burrow like icicles into
the oval windows of my brain.

V.
Like a quark caught in a sandstorm,
I am a slave to this slaughterhouse imagination.

Out of the long-haired sky,
with its immutable roots of gray,
come the dreamscape machines,
wickedly blooming across
the black-drop skies of the
interstellar void.

Oh, the brittle brilliance of a mind
held up on chopstick stilts,
of a mind that reaches deeply
into the sea of writhing photons
only to pull out the wistful
sound of entropy laughing.

VI.
Home is shelter,
the mind a prison.

I feel it in my backbone.
I scratch it into my skin:
the soft breath of a trillion outstretched stars
is the flame in which I burn.

I feel it in my backbone.
I scratch it into my skin:
the soft breath of a trillion outstretched stars
is the flame in which I burn.

Illusory Free Will Overdrive

I.
I can lift these eyes
into the blueness of
the thin atmospheric curtain
that surrounds us,
for I am a shipbuilder
trapped inside the bottle of time.

I can coat my mind
with the armor of positivity
yet things that have tended
to emerge pupae-like from their
cocoon of indifference still darken
the ancient skies with the breezy tremors
of anxious butterflies.

I am nowhere
and everywhere
at the same time.

As thunder cracks the hull
of my tilting memory ship
threads of lightning explode
into a trillion scattered fragments
of oblivion.

II.
Things that have tended
to emerge pupae-like from their
cocoon of indifference still darken
the ancient skies with the breezy tremors
of anxious butterflies.

We are nowhere
and everywhere
at the same time.

Yet we can lift our eyes
into the blueness of
the thin atmospheric curtain
that surrounds us:
for we are shipbuilders,
trapped inside the bottle of time.

Skin To Skin We Embrace The Epiphany Of The Galactic Supercluster

From the shape of your eyes
silky tendrils of meaning erupt
and quiver like whispers of the fifth dimension
as our fiery emotions leapfrog like quantum ghosts
tunneling through the riverbanks of life.

As the universe flies apart exponentially,
we delve deeper into the darkness,
dark matter holding galaxies together,
dark energy flinging the cosmos apart.

In the furious shimmering of hours
our imperceptible bubbles of astonished matter
gallop faster-than-light through the sparse galactic voids
until halted by the towering entrance
of a billion swirling kingdoms.

As glorious radiation cascades into our minds,
we ride this cosmic staircase higher.

Tethered to the ether by the motherly grip
of a central supermassive black hole,
each bejeweled galactic step sparkles
with the light from billions of distinct star systems.

Oh how our cold and fleeting faces
rise to meet the churning night sky
like lizards racing up cliff walls,
desperate to warm themselves
upon the rocks of simmering consciousness.

As our touching hands try to stabilize these fragile heartbeats,
the realization that everything emanates from a single point
glistens in our eyes with tender emotion
as we sway softly to the familiar sound
of approaching spring rain.

Our mutual velocity binds us together as we expand inwardly,
sending sonorous songs about singularities
rippling into the stratosphere of this poignant pale blue dot
that we walk upon with tremendously trembling limbs,
tremendously trembling limbs.

A Rainbow That Begins Where The Gravestone Ends

I.
I am a turbulent automaton built from bones and blood,
whose voice is distilled from molten hiss
of an infinity of lonely hearts.

I flee from the curling fingernails of time,
madly circumnavigating the hallucinatory hedges
that line this cosmic garden maze.

(Yet I shall emerge
from star-core
again;

my mass
will be greater,

heavy with hope
that cannot burn out.)

II.
As we fell into togetherness
we were reborn as galactic birds,
gliding effortlessly upon the solar wind.

Oh,
how the parapets of our eyes crumbled
as the sudden impact of morning skin
blasted a crater of joy into the landscape
of our dawning minds!

(We shall emerge
from star-core
again;

our mass
will be greater,

heavy with hope
that cannot burn out.)

Time Is The Garden And We Are Its Seeds

I. 93 Million Miles From The Sun, The Moon Is Born

Watch the flux of vomiting geometry
as an enormous asteroid smashes into planet Earth.

The dusty contours of space-time slowly
transform from a whirling and undefined mass
into a chalky orb of gravitational servitude:
light begins to reflect onto the planet below.

II. A Fully Cryogenic Design That Digests And Interprets Starlight

Adjusting aluminum optics
for the spectrograph.

One moment please.

A superstraw born of metal and glass,
the Keck II Telescope stares upwards with tunnel vision,
screaming out reams of data.

It is mankind's measuring cup of the cosmos,
quantifying the recipe of the natural universe,
one scoop of ancient light at a time.

A single grain of sand slips
thoughtfully through an upturned human hand.

III. The Embers Glow With Fiery Resignation

Oh, collectors of photons,
let us distort the universe's fury
with the bent mirror of our writhing humanity.

Let us visualize
how Pluto coalesced
its moons Nix and Hydra
by simply reversing the spin of time.

The moment we pierced the truth
of the black hole's volatile inward bloom
we carved a shimmering lodestone monument
into the expanding walls of space-time.

For even here,
especially here,
in the darkest centers of deepest gravitation,
this huddled and compressed matter
still retains an undeniable connection
to the rest of the universe.

A palm downturned
feels the roar
of the fire.

IV. Where Fireworks Explode Inside An Untamed Mind

Every eye-spot in the universe
evolved to let the photons in,
to interpret this Rorschach life,
a life spent sailing atop an azure globe.

Hurtling away from the rest of the universe
it seems impossible to feel the wind of an alien sky,
but dig deep enough to unearth the truth:
even a primordial alien fossil
is just dirt and time,
dirt and time.

As the universe shoves fertile minds forward,
existential rage simmers to a boil then overflows
with sentient messages of hope and despair:
boldly we stitch our defiance
into the black patchwork void.

Oh, that this quilt of joy and spite
may someday be reassembled to defeat endings,
to let us drink heartily from the salty waters
of a painfully self-aware mind.

Through a pinhole we watch
as the midnight ecosystem disintegrates;
a trillion tongues catch
and absorb the fragmented pieces
as the universe stomps onward:
the hydrogen-fueled breath
of a newly outstretched star
silently dips a billion future minds
into the event horizon.

Gravitational Lensing

I.
Skull ovals widen their electromagnetic net,
dragging *her* into my line of sight like collateral damage.

Her smile subtly burrows through me
like a Planck-scale gravitational wave,
evoking quantum goose-bump ripples
that carve epic monuments into my skin.

She inhabits my outer shell
like a master puppeteer,
marshaling my limbs to dance
to the beat of the prime singularity.

I am a flimsy sheet of sentient parchment
on which the cosmic background radiation is written.

II.
Whenever inertia draws her near,
space-time creaks and hisses
like an old house blown by the wind.

The same way that the curvature of Earth red-shifts
the lemony midday sun into a rust-tinged evening sunset,
she pinches off my shocked heart like a cluster of dusty grapes.

Untethered to the supermassive wounds of lost love,
the amorphous boundaries of the cryptic past
dissolve like a magician's failed finale.

Her spring face and energetic eyes
reconstruct my depleted center
with the unstoppable momentum
and unimaginable complexity
of a swirling galactic supercluster:

my halted bloodstream and choking lungs
suddenly refill with thin blue atmosphere
as I bathe in the circularity of lust.

III.
Her silently approaching silhouette stirs
this surging shipwreck of consciousness forward,
releasing balloons of steely desire which rise
like a flurry of bioluminescent corpses
from the crushing depths of the sea floor.

Her sweeping vista expands before my eyes
like desert mountains upturned by the tectonic drift of time.

Curled inside the light-starved cocoon of night
my eyes climb over her glacial body with the frenetic motion
of lizards scrambling up a cliff face to sun upon the rocks.

My heart is a flaming tongue,
piercing the night air.

IV.
With an alluring gaze,
she sprinkles my inner solar system
with flickering purple discs of unstable antimatter
that orbit near the surface of my flushed face.

As she leans in for a kiss,
our opposing particles spectacularly collide:
soon all that will exist in the universe
is the supernova remnant of our Love.

My jack-hammered heart glistens
like the gnarled trunk of a mammoth alien tree
whose drooping boughs still remain
despite a thousand years of winter lightning
and a full season of flooding summer rain.

Minute Variations In The Cosmic Microwave Background

I.
As moonlight radiates over us in chalky waves
the ubiquitous tendrils of sensuality
anchor our lovestruck eyes to the starry landscape above.

The atmospheric interference
causes photon-streams to sputter.

Bundled up in the cosmic equation
our essences quiescently hover
below the geometrical blackboard of night.

Here in the heart-bound silence
our lips dissolve into the starlight's calm surrender.

II.
Soon we are transported to a stupendous void
where a million light-years of empty space
balances out the swirling mass of a single Galactic Supercluster
which shines down like a windblown candle
from the all-embracing canvas of Dark Matter.

The arms of night always arrive carrying
the ubiquitous eyes of the universe in its darkened palms.

The arms of night always arrive carrying
the ubiquitous eyes of the universe in its darkened palms.

III.
As we join hands
our thoughts dry up
and drift away like tumbleweeds.

The scaffolding of Dark Matter must imperceptibly shift
as each unique ripple of consciousness
bursts forth like a glass dolphin
into the slippery rainbow skies,
into the slippery rainbow skies.

As our nearing lips adorn the universe with desire
a million neutron stars collide,
a million neutron stars collide.

Sometimes their Quasar emanations
produce an astounding deluge of unimaginably diced matter
which happens to gaze in our direction:
it is then that we see how even a star-burst
is merely a matchstick tossed at light-speed
into the river's breaking current,
into the river's breaking current.

The Escape Velocity Of A Rorschach Sunset

I.
As the fiery half-eaten orb
melts farther into the mountains,
the heart shudders in astonished jolts.

A gilded feast of morphing shadows tempts
the pattern-hungry brain to arrange
dozens of weather-beaten points
into monstrous faces of jagged rock.

Vectoring like a maniacal dragonfly
the eyes construct (and deconstruct)
tensile bridges of silken meaning.

The shifting boundary of the rugged terrain
slips in and out of focus;
the cerebral cortex strains
like an under-powered microscope
scanning for a fistful of wind-strewn prions.

As night sounds alight
from their distant cliff perches
the velvet handcuffs of night
ease onto the day's dumbfounded wrists.

II.
Right now,
on the opposite side of the planet,
day swallows night.

But here,
as the crackling firelight
concedes to the ashen skies,
the entire mountainside heaves
like a labyrinthine lung expanding and contracting,
expanding and contracting until finally,
in a subconscious spasm of breath-stopping resolution,
a flood of imagination floats perspective higher:
twin spires spike skyward
like the saber-toothed fangs
of an 800 pound Smilodon populator,
conjured larger than life
to stalk the freshly darkened horizon.

III.
It was as if,
over the millennia,
the beast had evaded extinction
while scaling the mountain peaks
from the bottom up.

As its rock-ribbed limbs
slothfully stumbled skyward,
an avalanche of tumbling stones
lazily colonized the landscape below.

And now,
the backbreaking journey complete,
its insatiable jaws rise
with the curtains of night
to prey upon the starry skies.

As Our Thought-Gardens Bloom, Jupiter Opens Another Of Her Stormy Eyes

I. Sometimes I Awake With Weeping Eyes Of Jade

There in the brooding darkness
pitch-dark lacerations appear in twisted streaks
against the mirror of my spine.

The tangled knapsack that hides
this hideous soul-carnage tumbles open
and the mirage of self dissolves:
as my fingers begin to puddle in circular rings,
the watery vibrations of this asteroid-filled symphony
crescendo into a wall of bitter violins,
ripe with the tender heat of resignation.

II. Whittling The Worn Wood Floor With Another Wandering Footstep

Stalking past the reaper's molasses trap of gurgling regret
a haunting face appears and disappears in the black lava
like a million-year-old leaf,
unearthed and instantly oxidized
by the quicksilver rays of the morning sun.

Yet still I lift the veil,
still I lift the veil
just to feel the fleeting outline
of a human face bathed in obsidian,
drowned in the slow-cooked crude of consciousness.

Muddle,
muddle through
the eye of the needle
once more.

III. Here In The Trenches I Await The Killing Ether

Corpse rage clouds my eyes.

Icy thought-daggers hover relentlessly above,
coating this diamond sphere
with the spiked gravestones of indignation,
the only ammunition I need.

Calm as angel's breath
I aim squarely at the cosmos
and ease the trigger back.

From atop this splintered life-boat,
set adrift on a sea of uncertainty,
a shot rings out into the void.

Calm as angel's breath
I aim squarely at the cosmos
and *ease the trigger back.*

In the quiet corners of quantified time
silence sheds like the rattlesnake's skin:
the outer shield has been left,
but the raucous chorus still remains.

The outer shield has been shed,
but the raucous chorus still remains.

IV. The Noose Of Particles That Surrounds Our Minds

Physics,
that vicious mistress,
is both the waterfall's end
and the river's icy-mountain beginning.

Even the wildest gyration of a poet's arrow,
launched haphazardly towards a simile-strewn heart,
is descended from her bountiful waters.

Wielding the icy blade
of forgiveness with flaming palms
renders resolution impossible.

V. Wring Me Out In Waves Of Hate

This skull juice
is the ultimate poison;
let it coat the throat of this universe
with noxious dark matter.

My heart,
forged from the unfathomable cauldron of time,
is shaped like a trillion question marks.

My mind,
reassembled from a swarthy jet of star radiation,
is a prismatic lodestone sword:
with unforgiving effervescence,
it glimmers in the chill of the night.

VI. Pruned From The Trees To See The Skylight Surrounded By Black

Sometimes I shred
the obscuring clothes of humanity
just to beat the rocks like the primate I am.

I vocalize,
a furious four-limbed sculpture of carbon
shouting from inside the atmosphere's skin.

The formula is cruelly diaphanous:
god is a zero,
a placeholder denoting
all that is vast,
all that confounds
a single pair of trembling hands.

Yet,
there in the half-light
we surf upon the cold wind stream,
propelled by the flamboyant warmth
of our jackknifed hearts.

VII. Flourishing In The Quiescent Light Of A Soaring Moonlit Night

Sometimes we yearn to un-know,
to return to the elaborate facades
that cloud the skyline of ideas.

But this razor-vision,
swiped from Occam's lips,
it reaches into absolute zero
and pulls out a steel heart
brimming with elapsed regret.

So I vocalize,
a furious four-limbed sculpture of carbon
shouting from inside the atmosphere's skin.

I call out for a sentient star:
a giant machine like us,
born *into* majestic isolation.

Together,
we are atomic siblings
bathing in the flamboyant warmth
of our jackknifed hearts.

VIII. And Sisyphus Wept Intergalactic Tears

Sometimes a galaxy is a speck
caught in the eye of a supple colossus,
a Herculean statue of light,
littered with the fruit of self doubt.

Yet the size of its mind-terror mirrors our own,
and eventually we must reunite
in the brotherhood of blood:
cracking rock after rock after rock
against the slavemaster's chains.

Together We Suck The Poison From Our Wounds And Spit It Into The Sky

I. These Heartbeats Are Made Of Bark And Tears

Here inside
the carbon-stained
cliffs of my aching mind
the bustling time-spiders
inject their venom of oozing seconds
and shape-shifting moments
into my Rorschach consciousness.

(There is a healing whisper
forming on the lips of the wind.)

Blood like paint converges
from the battling hemispheres of my brain
to rain down from my eyes
like a syrup of agony that forms
a flailing field of rainbow droplets
which splatter against the fluxing fault lines
of my tectonic heart.

(There is a healing whisper
forming on the lips of the wind.)

II. This Love Is A Tourniquet

We ascend like angels
across aged castle steps,
spiraling away from the dungeon-like emanations
that arise from the dead and defeated pupils
of the bastard children of time.

Like the prismatic eyes
of the floating dragonfly
I capture all the stages of your ascent
from innocent to carnal,
playful to maudlin,
frightened to blissfully content.

And now,
as the wind delicately tramples
the moist corners of our trembling lips
we drift towards the water's edge
to reclaim the calming language
of swirling leaves as our own.

As we speak in forest tongue
each syllable softens our anxious faces
until they suddenly split like a waterfall
to reveal our hidden flames of longing:

with bare feet and exposed hearts
we begin to fire-walk over the tendrils of creation.

III. A Thirst That Cannot Be Quenched

As love forms from the smoky fruit
of our smoldering body-friction
we dissolve into each other's arms,
slipping one molecule at a time
past the palatial sieve of time's icy fingers.

As we disappear into
moments yet-to-be
each future possibility
sends us stumbling
toward the haunting reflections of our eyes
which gently meander down the distant waterway
like faintly flickering paper lanterns,
whose delicate murmur is:

always homeward bound.

This Is The Silence That Strikes As A Dagger Falls

I.
Upon awakening
my skull feels clustered
with the deadwood
of dreams.

Raising a lightning-soaked hand
to my eyes I am suddenly buried
by the approaching rumble
of a swaggering summer storm.

Stepping outside
into the midnight mist
the trees look like logs
carved from clouds
of interstellar gas.

Gazing upwards into
the blurred atmosphere
my star-drunk thoughts gallop
through the expansive and opaque landscape
as my legs shiver and contract
as if yearning to outrun
the turbulent shell of sky
that encircles us all.

In the frenzied flutter
poignant flashes of thunderclouds
tilt the stained-glass revolver of my mind upwards
to marvel at the melting moonstone above
which looks so bioluminescent,
like a thousand year old Honey Fungus
leaping the eight light seconds of distance
by sliding down the ubiquitous root system
of expanding space-time.

II.
As my cheeks overflow
with tears from the sky
I pierce the livid sapphire ceiling
with the pain from my eyes,
recalling how we once huddled together
in the explosive arms of night,
unafraid to bask in the eternal swerve and sway;
content to marry our wounds to the phase-shifting sky
as we attempted to untangle evolution's straitjacket of consciousness,
one thread of free will at a time.

It was then that an asteroid field of gray light crashed into our eyes,
injecting our mirrored gaze with such tender momentum
that soon we ripped into the heaving skies like a pair of wiry hands,
slowly unfurling an underlying layer of painted canvas
that resplendently filled us with the irrepressible buoyancy
of a blazing dawn sky.

III.
As time stumbled to a halt,
the fabric of the cosmos
became gilded into the handle
of us.

Your imprints
drained in oily whirls
into my emotional center.

And into the porous medium
of your receptive mouth

I planted an orchard
of fruiting desire.

How To Escape A Universe That Steals Its Smile From The Hyena

I.
We all trip violently
into the interstellar void
only to get sandwiched
between a billion galaxies still sticky
with the invisible glue of dark matter.

For we are all just meals
to the lumbering minions
of the universe.

Drop your ear groundward
and listen:

the bone crunchers
are approaching.

Their fangs slip disdainfully out,
teeth full of whirling clockwork gears
and life-sucking years as they rumble closer,
ever closer.

II.
I dry her tears of discontent with kisses
that lovingly chase the curve of her spine.
I slip my fingers in between her lips.
I slide my tongue down her shuddering back
as a rainbow of colorful stars swallows my eyes.

Anxiously I await a breathy response
but instead her silhouette melts into silence
as time leaps forward and I am left resplendently alone,
whispering silky nothings to myself,
cutting out my own heartbeats then crashing them
against every windowpane I've sat listlessly by,
grasping for unattainable moments,
scraping fingernails of yearning across this jagged forehead
which rises and falls like a lung-shaped junkyard
full of half-finished metal sculptures.

Suddenly her smile returns like a vengeful sunrise,
stripping the darkness and refilling every lake
in our watery constellation of desire.

I paint onto the canvas of her body
a ruby mountain that shimmers like songbirds
serenading the daylight as the growing tremors of touch
shake the wisdom from my mind,
leaving me joyfully imprisoned in a cage of delight,
freed to explore the flushed terrain of her welcoming body.

III.
Yet the beasts always bite back,
brutalizing lips and fingertips,
pulverizing dreams into scattered layers of dust
that quietly pirouette to the dessicated rhythm
of a matter-blasted moonscape.

There in the bushy hillside of our hearts
we burn in the brushfire of malcontent,
spurning every helping hand,
for each one seems to hold a silver dagger
bejeweled with sprays of blood left
by the spent foot soldiers of sentience.

Wherever the sky spurns us,
we flicker,
flicker as the asteroids turn.

Whenever this ash heap of a life explodes into the atmosphere,
our faces become gravestones formed by clouds,
our eyes impact craters left by the crime of the human mind.

So smash us together
with our antimatter twins,
so we can incinerate the rings
that shield Saturn's skin.

A gash rips open the stellar curtain,
sending our memory-stained limbs hurling towards the Oort cloud;
yet instead of becoming inert spare parts once again,

we feel the glorious blast of ultimate release
as a supernova shuttles us past the event horizon
of a supermassive black hole:

time
glacially churns
to a halt

the fabric of space
implodes

shrinking so powerfully into a single point
that even the galloping legs of time
are severed

splattered
against the walls
of oblivion.

IV.
oh,
sons and daughters
of geometry

this
is where we belong

halting

the stream
of years

snapping

the fangs
of fear

singing
our frozen song;

returning
to the beginning

by the sheer force
of togetherness;

exploring forever
like future astronauts

whose hands haunt
the kingdom of absolute zero

whose joyful tears
of ripened discovery

hang like amber knives
over the heart of a singularity

The Behemoth Universe Versus The Entropy King

I. The Dancing Legs Of Now

Caught like a wiggling worm
in the sticky web of space-time
we flow steadily down the emptying hourglass,
descending hungrily past the sleek curves
of our ripened anticipation
and into the boisterous limbs
of the present.

II. Glancing Upwards At The Flames Of Rejuvenation

In an instant the pinpoint
photon streams of darkest night
vanquish us deep inside this thirsty,
supermassive black hole.

Inside this brutal vortex of wanting
space-time swallows, fractures,
humbles: reducing all complexity
to a singularity so reminiscent of
the beginning.

Yet even as the majestic eye
winks in measured concentration
the cadence of the billowing arc of time
is elucidated not by the passive sieve of sight,
but by the master of meaningful connections:
the mind.

Each single time-blink stokes
this fiery thought cocoon forward,
until the molten continuum of electricity
that we call consciousness
pierces the boundary and
gives birth to this precious moment.

III. The Elements Of Sentience

Energy dissipates
as pockets of extraordinary life
erupt bravely into the darkness
like the call of a lone trumpet wailing,
wailing into the deepening night.

Even now we labor step-by-step-by-step
as the journey slopes steadily skyward:
here up high in the foggy spires of harrowing self-awareness
we watch order and disorder expand and contract,
expand and contract to the sooty rhythm
of the coal-hearted skies.

We are sentient observers
enmeshed inside the vibrating lungs
of this universe.

As the energy flows converge
into the boundless waters of this ebony ocean
we yearn to wrestle the abyss into submission,
our untamed eyes brimming with righteous indignation.

We are sentient observers
enmeshed inside the vibrating lungs
of this universe.

Together our blood-filled fists
rise up to smash the emptiness
into a trillion lodestone splinters.

IV. From Another Dimension A Disembodied Voice Begins To Sing

Oh, beloved kin
who share this curious skin
I feel your vibrant chorus rising under a white moon,
for I am the Entropy King.

Oh, my ruby-hearted friends,
I've swallowed the silence of space again and again,
thrashing against the windless walls of this expansive room:
for I too have dizzily circled entropy's ring.

V. Dreaming Of The Entropy Queen

Yet
here in the black-splattered sky
I anticipate wholeness
as inertia draws her heart
nearer to mine.

As life fluxes around me,
I await the swirl and hum
of her velvety gaze.

For as long as the universe
has molecules to spin,
I shall await my queen.

Like a silver butterfly descending fitfully
from a fluttering breeze,
I anxiously shelter hope
in the time-weary lines
of my trembling palms.

VI. Love Arrives On The Wings Of Billion-Year-Old Light

A fold erupts in space-time,
a wormhole traverses
the staunch eons of night.

*Crystalline trumpets herald
the arrival of my Entropy Queen.*

*Together we serenade the local galactic spiral:
while the vibrating starlight spells out
the physics of our birthplaces
we join hands and close our eyes
as the dizzying gallop of space-time
draws us deeper into unity,
deeper into the vast cerulean sea
of our blooming subatomic smiles.*

Here in the haze of interstellar dust
we revel in the joyous ether,
bathing in thin streams of matter
that cascade into our invisible eyes;

we light the darkness of space
like a gas giant's swirling eye gone supernova,
elucidating the invincible heels of this lockstep universe
by channeling the pinpoint rage of the living.

With whispers and screams of loving affection
we scribble onto the blackboard of bent space
in the mathematical language of a pulsar's magnetosphere:
E for the electromagnetic energy in our touch,
M for angular momentum in our wild embrace,
V for the angular velocity of our softened heart-edges.

A fold erupts in space-time,
a wormhole traverses
the staunch eons of night.

Somehow,
we have unstitched
the fabric of space-time
with the yearning in our eyes.

VII. She Is My Compass, She Is My Queen

Astonished again and again by existence,
we strain to decipher the detritus landscape
that dots the hazardous curves of love.

How we tremble
before such majestic displays
of the universe's billowing energy bouquet!

Life,
so pregnant with yearning.

Love,
the north star
in this awkward journey.

Still,
I remain wholly unsatisfied
with this blind architectural design:
for I have died.

VIII. Patiently Awaiting The Singularity

Invisible crypt,
I've bottled my queen's timeless swoon,
accenting her volatile essence
with a flower's microcosmic bloom.

She, a ballet dancer forever spinning
in sinuous rotation near the edges
of the behemoth universe.

I, a dormant speck of geometry
hiding in the momentum of her orbit,
content to await the moment
when the mournful forces
of her tender pirouette
pull her too far from safe harbor.

For it is then that
I summon all my remaining strength
to apply a balm of opposing momentum
and orange blossoms to her graceful cheek.

It is then that the Entropy King
resolves and unites once again
with his Queen.

It is then that,
from the perspective
of an outside observer,
time slows to a heartening crawl
as the infinitesimal calculus of our union
dissolves the barriers of space-time,
shuttling us into a cocoon of joyous escape.

There we tunnel through the love-soaked ether
on the cloaked wings of ecstasy,
there we relinquish the tightly-gripped reigns
of this universe and disappear entirely *into another.*

IV. Sifting Through Shards Of The Eternal Self

Diminishing Returns From The Elixir Of Consciousness

I.
It is the stillness
that defines us.

Pensive moments of calm may suddenly burst,
releasing shards of existential terror.

II.
In the blinding light of self-knowledge,
blood-echoes crash in waves against
a faltering castle of awareness.

Stalked by the diamond coyotes of thought,
a quiescent heart creeps stealthfully
across an arid desert of isolation.

Beauty Is Nothing But The Beginning Of Terror

I. The Poem Lodged In My Throat Is In The Shape Of A Dying Heart

When loneliness cascades down your crumbling halls of thought
like a fluctuating horde of cave-bound bats,
your disused wings of delicate yearning
no longer shimmer like jewels in sunlight:

for sensuality has been strangled
by the immutable and unflinching hands of time.

II. Looking Up From Love's Basket Of Decay

Death grips my sin-hungry fingertips like a vice,
so I lick my nails as if they were blades,
carving my tongue into a gruesome sculpture of love beheaded,
the corrosive glint of the guillotine shining listlessly from my eyes
like a fiery bouquet of blossoming despair.

III. The Bloody Evisceration Of An Oasis Of Desire

Lust has been mummified,
and things will never again be like the vibrant butterfly,
erupting ostentatiously from the volcano of life,
but instead will now be like the skulking moth,
creeping and fluttering in the darkness:

for passion long ago bled out
over the shifting sands of circumstance.

As The Molecules Flow From My Chest, The End Draws Near

I.
Faint,
discordant echoes still rumble
along this dank corridor.

Yet here,
love is a slaughtered symphony.

*(For frayed and snapped
heart strings emit no sound.)*

Oh,
how the wooden corpses stare out,
their splintered eyes a jagged testament
to the coffin-shaped wake of emotional carnage
that inevitably rises from these murky waters of sentience.

II.
*Why must I own a heart
that always sloshes with destabilizing emotion?*

Soon I will take this cursed ruby lake and drain it,
replacing its unpredictable and spiteful waters
with the putrid flesh and bones of love's corpse,
whose gruesome waltz towers over me like
a million misshapen boulders of regret.

III.
Joy,
your rays of quenching sunlight have always been fleeting,
only occasionally penetrating my opaque center,
bursting gloriously forth in an effervescent bouquet
whose audacity is soon pruned by the primal frost of time.

IV.
Though long ago the siren's tongue was cut,
somehow her impatient song of death lingers:

wither,
wither these leaping flames
of tender courtship

smile,
smile the absurd smile
of the knowing

for there is no air
in this dessicated crypt;

there is only vacuum,
where there should be a heart.

If Only I Could Shield My Eyes From The Velvet Horizon

I.
When the flames of loneliness rise from your chest,
erupt from your heaving skin like an explosion of autumn leaves,
that is when the icicles of time stab spring whispers
into the gyrating center of your starving pupils,
which launch hungrily upwards towards
the unattainable depth of the haunting night sky.

Oh how your arms fold and unfold,
attaching and detaching your hands
from the throats of the enemies of sorrow:

for tonight is a clock tower without hands,
with you as the frozen centerpiece,
entombed in idle thoughts which parade wickedly
across the graying spectrum of your billowing imagination.

II.
Enslaved to the demon of biology,
dragged down into the hurting pools of desire,
this heart bathes like a newborn in a gasoline-fed fire.

Full lips that kill.
Bright eyes that cannot fill.

Full lips that kill.
Bright eyes that cannot fill.

I break promises here under the night sky,
here in the underbelly of the universe,
I let it all go,
and begin to care for no one.

III.
This being,
this vessel of twisting desire,
is a brittle sailboat hurled by the winds of temptation,
destined to crash again and again
against the crunching rocks of despair.

Hydrogen,
with its conquest of the stars,
with its primacy in the scheme of the universe,
trembles in my eyes,
quenches fiery oxygen
to become a teardrop,
undescended.

This is a tower of life,
these are the stained-glass scars;

her eyes are the hammers
that bring this edifice crumbling down,
crumbling down.

IV.
And whenever I awake,
the tendrils of future despair reignite,
for I am whole,
I am whole again,
a vibrant Sisyphus heart-bound
to mountainous boulders of desire,
destined to yearn for welcoming eyes and skin,
which would hold us together
like the bonds between stable elements,
if only you weren't a mirage in the shape of a woman,
shimmering so beautifully,
yet so cruelly,
tantalizing my spiraling heart with ephemeral promises
that flutter and disperse like a flock of birds,
leaving only a cloudy arrow of tender nothingness
which soars softly into the misty geometry of oblivion.

Permafrost Melts, Nematode Winks

1.
Methane bubbles rise forcefully
from the gargantuan clenched fist
of humanity.

The iron fingers of each finite digit of fossil fuel
steadily rust, one by one,
and soon voracious oxidative processes
will slowly unveil a culling diamond in the palm.

The dark matter of the universe
is calling you, tender primate soldier.

The sharpness of hydrocarbon ascent
is only felt on the way down.

2.
As you glance head-long into
the bursting shards of time -
realize that you are many.

In microscopic undulation
six million nematodes silently click and beep
throughout the saber-like ecosystem of your eyelashes.

You sleep to the whir of their complex
yet infinitesimal machinery.

You write environmentally gentle symphonies
to the writhing beats of their birth and death throes.

Flutter, flutter, twitch, twitch.

Each single wink from your tearless eye
disappears into the graceful sputter of geologic time,
and nothing will ever change the fact that,
over many candidates,
you were selected for living
by a breath-inspiring dancer:
the entropy-shaped kaleidoscope
of ostentatiously borrowed time.

3.
Ah, the three dimensional grace
of a non-flattened universe.

Just next door in two dimensions,
another universe flails away,
thrusting towards the consciousness
we have already received.

Flutter, flutter, twitch, twitch.

The sinking sail tied
to the mast of every hi-stepping heart
drifts ever farther into the destructive waters
of techno-worship
until even the mammal brain's ability
to adapt to nature is not enough
to halt the reckoning.

4.
The dark matter of the universe
is calling you home, tender primate soldier.

The sharpness of hydrocarbon ascent
is only felt on the way down.

A Bloodline Sharpened With Shards Of Rock

I.
Since the legs of circumstance kicked us here
we have been steadily unwinding
like the downturned eyes of the unforgiven
as they descend the cruel staircase of life,
one heart-blistering step at a time.

We stumble Cherokee-style
down our own personal trail-of-tears
with hungry bellies and screaming feet
as the brutal trail's edge knifes our centers,
punctures our lungs until they drain like a bag of sand,
filling time's footsteps with future diamonds.

The chariot of corpses rolls wickedly by
with babies once cradled in hands
left to be hauled away like broken dolls
whose eyes used to open and close whenever
their center of gravity shifted.

Earth sharpens like an axe
as the rosebuds diminish,
drift groundward.

II.
The curtain rises with ashen twinkles
as the morning star wanes
and bark frosted trees begin to gather daylight
through leaves destined to wistfully descend
past mushroom-speckled trunks.

We form a tidal wave frothing
with the charred breath of a million extinct species
that were poured into the callused corners
of the genetic ditch only to become
anachronistic archeological marvels,
broken pieces of ancient supernova explosions
waiting to be unearthed in even the farthest galaxies,
a distant testament to time's spent arrow.

Our jumbled particles silently race
into the vibrating decay like unseen owls
swooping into the crackling distance that separates us,
tying us together with infinite quantum strings.

These carefully painted cave walls
are formed of regret that
boiled out of the earth
like tipped over vials of blood.

Earth sharpens like an axe
as the rosebuds diminish,
drift groundward.

The Fleeting Buoyancy Of This Bubble Of Life

I.
Unafraid to ignite
this emotional kindling
I mine my eyes
for sparkling tears
that spiral heavily
into the jagged slipstream,
into the jagged slipstream.

I scream in shell-shocked agony,
knowing I am merely a wind-up toy made of brittle glass,
launched from the brutal cliffs of space-time.

As these razor-thin shards of consciousness
stab wickedly into the starkly widening expanse,
my free-falling heart becomes a rainbow-soaked nebula,
blooming with the fierce grin of fiery indignation.

II.
When lightning strikes
my dungeon-bound heart,
every vile wavelength storms
into the dying cellar of my eyes,
into the dying cellar of my eyes.

As electromagnetic radiation oozes
into my interstellar bloodstream,
awareness flickers haphazardly,
splashing the color of incalculable terror
onto the shrieking tongue of night.

III.
Shape-shifting fires creep up my neck;
the fervent flames emerge in waves
from the swaggering clock tower
that boldly buttresses the horizon.

As time clanks forward bony black fingers
greedily check and recheck my pulse
for proof of impending silence.

IV.
Still,
each night in the swirling shelter of dreams,
I gloriously command the piano keys of life
to rise like gravestones released from gravity,
to dance furiously as the night blooms,
as the night blooms.

Deep In The Sculpter Supercluster (Redshift 0.11, Near The South Galactic Pole)

I. First Movement

From high upon the ebony-black stage,
the fashionable, fluctuating quartz pattern
engraved in her chiseled robe flutters playfully
with the edges of the crowd's vision.

As the slightly famous word-painter
strides confidently up to the faux iron microphone
(itself an ironic hybrid of technological and geological evolution)
her seemingly artist-drawn eyes
bleed Digital Rainbow Tears in an amalgam
of emotion-pinching colors:

metabolism-arousing red
dissolves into harmony-inducing green,
fascinating permutations of yellow,
orange, and blue swirl
like a demented primordial soup
until finally an alternating dance
of stark black/white marks the eye-cycle's end,
and the soul journey's beginning.

II. Bridge Of Meaning

In hammering staccatos those dual slits of piercing,
those false-color irises of molten lodestone
measure the audience's worth in the blink of an eye,
and in a bravura performance she forges each word
carefully underfoot like translucent skis,
teaching them all how to descend
the Universal Mountain on their own terms.

III. Concerto Of Revelation

Suitably entranced by the iris color wheel,
the polyphonic word-flow begins to pour outward
from her crystalline lips.

Like a hallucinatory waterfall
splashing into the eyes and ears
of the quietly mesmerized souls below,
she weaves the burnt tapestry
of the physical universe into their minds,
spilling the space-black blood
of a million extant life forms onto their hands,
painting with their life-essence
an intense catalog of space-time residents,
from the the extreme gravity fields of black holes
to the intoxicating power of thrashing supernovae,
from the infinitude of suns, planets, comets and meteors,
to the dark matter and cosmic gas and dust
floating in the interstellar medium.

Sheer terror, sheer joy, sheer respect for life
drips drop by drop into the buckets of their souls.

Her voice rises high above her cliff-like perch,
an unparalleled cosmic teacher,
pressing her student's hands
against the bonfire of universal knowledge.

*"Watch as the fluttering flames caress and clarify
the expressive faces of your atomic brothers and sisters.*

*Here is where existence begins,
and here is where all life returns.*

*We are not forsaken my precious siblings,
for we are now, and will always be,
the kaleidoscopic lighthouse of life
which beams its collective eye
into every bejeweled corner of the universe.*

*As we unshackle this shimmering beauty
from its prison of darkness our blissful hearts
rise and burst like tender supernovae against
the astonishing splendor of the pillars of creation."*

A Duet Of Bittersweetness Sung By The Spider and Snake

I.
As the rabbits of indifference nibbled away
at the pansies of our shared dreams,
I foresaw the sorrowful melting
of your ice-sculpted form.

Like a storm of liquid flowers
I pressed the delicate imprint
of your dripping visage into meandering skies.

And now,
as the gravitons obliviously stream by
(whispering, wailing, wandering)
I am an asteroid-slug crashed into an enormous moon:
my life-force smeared in thin dusty reminiscence
across the memory-drenched foothills of the heart-torn.

II.
When the jackal's grisly grin crouches
like a mountainous cat,
a flush of neon purple wings scintillates
against the harsh metal vibrations
of this sinuous mind-cage.

As the anvil of time drops ever lower
down this ineffable gravity slide
we violently gorge on planetary mass.

As our eyelashes flutter and flicker
towards the infinitesimal Planck length
we contemplate the insane quantum jitters
that force thin metal plates together
even in the darkest depths of space.

III.
As this mind effervesces and this chest heaves and surges,
I see the snakes of absence shifting fitfully underground.

As consciousness whips serpentine swirls
into the wake of these iron heartbeats,
this towering bunker of sentience is
swallowed and regurgitated into
a sea of kaleidoscopic anguish.

I feel the serpents of absence
shifting fitfully underground.

Once more this icy carbon mind clumsily stumbles
across the ghostly tripwire of her eyes,
releasing sunspots that slither into every smoldering ruin of the past,
where every shadow dances with the devastating intent
of a bifurcated tongue.

IV.
Yet out of this brutal singularity of deprivation
I am reborn as the Entropy King.

For eons I held onto the velvet hammer of her smile,
walking the righteous path.

But now I can wait no longer:

I stalk the immutable gray with spider legs
that stretch across the universal horizon.

My web shimmers as I emerge
as a two-dimensional hologram
of filigreed space-strands.

I stalk the immutable gray with spider legs
that stretch across the universal horizon.

As I inject crippling poison
into the cheeks of space-time:
I rise in anger to destroy us all.

Crush the mind
and you crush the sky.

Crush the mind
and you crush the sky.

V. Imprints That Disperse Like Dandelion Seeds In The Wind

a speck of my heart was forged in the first star 13.62 billion years ago

1.
for one hundred million years
after the big bang

I gathered hydrogen
in the darkness

(when the fires of fusion finally erupted
I basked in the primal rays of the first starry sky)

2.
and before that
I was both matter
and antimatter

annihilating myself
with incendiary spasms
of exponential function

(until half of me
emerged victorious)

3.
today I am both particle
and anti-particle

somehow affecting myself
even halfway across
the universe

(thus I span billions
of light years)

4.
for one hundred million years
after the big bang

I gathered hydrogen
in the darkness

Listen In Silence As The Pitiless Crows Of Space-Time Scatter

1.
I am a tattered sheet
of human parchment,
nailed to the gnarled
and elephantine tree-trunk
of imagination.

*None shall ever know
all that I am.*

2.
As the feathery cloak of night
calms these floundering eyes

my aching heart
becomes a skylight

each thought lurching high above
the trampoline of my mind.

3.
*I am a sliver of sunlight
dancing into a prison cell.*

*I am the crunch of leaves
under a prowling moon.*

*The heart-noise I make
sounds like a squadron of crabs
skittering across a neon sidewalk.*

4.
*I am a cracked anvil vectoring through
the hollow space between the stars.*

*I speak only in the black language
of galactic reconstruction.*

*From a billion swirling springtimes
I burst forth with riotous effervescence,
the culmination of countless supernovae.*

5.
For eons I hibernated
inside the cavernous belly
of a stellar nursery.

Now,
crushed into heavier atomic configuration
by the brutal jaws of gravity,
I surf the blast wave,
barreling wildly into the expanding unknown.

This Is The Shape Of How I Inhabit An Empty Sky

I.
I am a sun-lit sailboat,
whose mast is buttressed by a concrete heart.

(Where will this journey end?)

II.
I am a pair of iridescent insect wings,
fluttering above a flush of dewy leaves.

(How many more times will I feel the kiss of dawn?)

III.
I am the steady rise and fall of the sea,
inexplicably bound to gravity's clockwork respiration.

(How can I survive these grinding gears of existence?)

IV.
I am a spiraling galaxy,
cradled by the shadowy arms
of dark matter.

*(How can I love without hesitation,
when my center is anchored by a singularity?)*

V.
I am a sonic boom of consciousness
barreling down the quantum tunnel
that merges space with time.

(For how long shall I remain?)

VI.
I am
a melting
hourglass

whose irregular form
is merely a drunken silhouette

of the shape

of how I inhabit
an empty sky.

my heart is a flame-dancer wandering along the distant riverside

1.
her feminine curves broadcast
ripe messages of conquest
and luxurious harmonics

delaying the reclamation
of the darkened silhouette
that haunts the boundaries
of my tattered cloak of isolation

2.
as stars gaze down into my eyes
the connections abound

light shines
in tremendously
tiny increments

the geometry suffocates
like the emaciated outline
of a newborn's smile
cleaved into the halted
black of night

3.
she presses a pair of hands against my ears
but cannot overturn the fevered chariot race
that rumbles past the dog-eared page corners
of my careening crypt of a heart

4.
as the fading singularity
of her whispering fingertips
lazily dwindles into the glacial stare of night:

I reach into the rings of Saturn to liberate
the boundless energy from a handful of matter

refilling our cup of wanting
until it overflows

until it overflows

oh how your quenching eyes still streak my watercolor skies

1.
a sculpture of melting ice
evokes the elegance
of your face

boldly
you rise from my inner canvas
like ancient architecture
rediscovered

2.
a flurry of tender brush-strokes
summons the beckoning lines
of your supple body

luxuriant fields of wildflowers
suddenly surround the walls
of my castle of thought

3.
as the trembling landscape
of the present crumbles

nostalgic rivulets of silver and jade
transport me to an island universe:

here all that remains
of the space-time continuum

is the sweet coo of your voice
and the cool crisp glow

of midnight snow

Time Filled My Pockets With The Glow Worms Of Momentum

1. The Sound Of A Teardrop Distilled Into Alien Ears

the faultless sun
sure shot us
an indecipherable gaze
that day

we drifted to the
atmosphere's edge
naked

like an orchid blooming
against the defunct metal
of an orbiting satellite

we were left stranded
on the rooftop of the world

where regret pools
in wailing shadows

yet
together we formed Pterodactyl wings
and flew away on thin sheets of skin,
the prehistoric wind brimming
with the fitful sleep of ancient matter

2. Her Superior Genetic Architecture

she
a black-skirted spaceship
hiding in the glare of the sun

stepping lightly down
from the clouds

the brightness of her face
swaying under the slow-churning skies

beneath her
doors creak open
in anticipation

the brightness of her face
swaying under the slow-churning skies

the world greedily swallows
her rings of ambrosia
in savory lumps

leaving nothing
for the scurrying insects below

when you left I asked the time-thieves to repossess the staircase of me

1.
swipe it
from my facial expressions

steal it
from the very way
I walk

you can have my
essence

I don't want to hold
these reigns anymore

2.
oh the times I thought
we were mutually lost
in the shuddering overflow:

when you memorized how
I diminish in the afternoon

or how I replenish
in the moonlit splendor of night

or how the lines
in my face would recoil whenever
fate emptied our cupboards of joy

3.
yet now
I recoil alone

for no one stands here
anymore

today
the deed sold to circumstance
has expired,
melted into stale equilibrium

I feel pushed off of
life's balance beam

abandoned during this
closed-door performance
for one

4.
so grab your pencil and
draw me as the freewheeling motion
in your hip's sway

sketch me into riotous caricature

dip the rustling branches
into the mountain's shadowy inkwell

leave me disjointed,
listing to one side

a shipwrecked star
afloat in the night sky

With A Playful Flourish Of Her Smile The Forest Nymph Wields Her Orb Of Power

1.
her writhing beauty
restrains the color burst
of her flowing spring dress

absorbs their
eyes of longing

retraces the rhythms
of their forgotten hearts

for it was her form
that spun the planets of desire
into collision

she
the eroticist

she
the wheel's spokes
unbroken

holding in place against
the endless rotation of time

running naked
over hesitation's grave
as her last moments
of childhood rain overflowed

spilling her ripening vessel
into the day sky

2.
reversing course
she heads groundward
to dance in the streams
of playful invention

the spherical sun
warmly sags as she bathes
in their rivulets of wanting

then
something in her
remembers

a lady shouldn't
move with such turbulence
when a crowd of hungry irises follow

but her bloom of motion
remains unstoppable

perhaps
another day
when the mud of indifference
ferments

and she learns
of darkness

but for now her ripening heart
ascends to the cerulean vault
on the winds of wild abandon

unchaining
the drenched cheeks
of sorrow

releasing every planet-bound vessel
from blame

3.
she saves the buckets of spite
for tomorrow

she
a hurling moonlet
parading away from the stage

pickpocketing the heart
of every spectator

(*like satellites*
they gather whenever
she is near)

and at night
when dream-time crawls and dashes
through her moistening subconscious
she delights again and again
in the sensual sounds
of devious surrender:

the swoosh a dress makes
when striking the forest floor

How To Lose An Argument With The Monsoon Sky

1.
on this blood blossoming highway
my heart is a steam engine barreling onward
as the sound of air

violently decompressing

floods the passing terrain
with the crimson wailing
of indelicate endings

2.
trapped under the wreckage
of her defunct smile

I met an angel with a bow
made of ancient bones
and poison-tipped arrows
imprinted with the double helix

as the black soot of agony
caked onto my face

I saw a mutant devil
strumming his dozen arms
like a giant harp
made of centipede legs

3.
here on the stretcher

as my stolen oxygen streaks
through the air like burning tire treads

I shall await your returning fingertips
like a newborn awaiting resuscitation

for here

the licorice night
chomps down on
the iris-heavy calm

which once catapulted
this singing skull tower

from yellow to white
and back again

from sun to moon
and back again

4.
I,
with a mind
of a cyborg child

I,
with limbs made
of broken robots

am gone from the fight

returned to the great
filthy underbelly

from where I recall the inquisitive eyes
and the rare but admirable personalities
from the perspective of four thought-soaked legs
which splash and splash inside swelling puddles of rain

5.
as if the atmosphere
itself was saturated

like the pith
of a rare citrus fruit
that shone like purple diamonds
hovering over a pink skyline

I vomited the colors
as time carved my midsection
with the blade of living

then dried my organs
into tea leaves

to be soaked and sipped
by the slothful spin of the earth
by the mindlessness of the water-hungry trees

6.
fate melts into thickets of disguise
as you approach the avenue of despair

so I
turn off this rain

of consciousness
and strain

and as the escape hatch snaps open
the skeletal black

rises
like
ebony
dinosaur bones

swarming into the killing skies
swarming into the killing skies

7.
I see an angel with a bow
made of ancient bones

I see a mutant devil
strumming his dozen arms
like a giant harp
made of centipede legs

I watch from high above
as the artifice of the world
slowly exits from my body
in smoky kaleidoscopic ringlets
that playfully drift towards me
like a jester's mischievous smile
like a jester's mischievous smile

Juggling Sunrise And The Abyss, My Eyes Pop Like Blisters Of Color

1.
in the velvet distance
a sequence of yearnings
emerges from the zig-zagging bees
of frantic motion

2.
wherever the green grenade of spring
explodes into bounty
is where I want to be

feeling the exhaling light
of a mile-high rainforest
welling up inside my heart

but the path to love
is strewn with mines
and each reckless step
calls down lightning from the sky
calls down thunderclouds
soaked with the gasoline rags
of cursed wisdom

3.
yet
a kiss
planted in
a weeping eye

releases the soothing breath
of rainforests

opens this clenched fist
stuffed full with mossy heart clumps

resuscitates
this flatlining humanity

for the mirrored burning
of stars and minds
continues to light
our way forward

4.
if we gather the sands of synchronicity
from the corners of our eyes

then adorn them onto
these diamond wheels
of hurt and kindness

maybe the shimmer and the shame
of emotion will cause the disintegration
of this destructive machine
of sporadic tenderness

5.
though
the billion needles of regret
leave their mark,
I dream of being paved over
with kaleidoscopic scars of the present

of strutting
with painted feet

of being
perfectly at home
like the eyes of dolphins
captured in mid-air

6.
so let's lay waste
to the false equilibrium
that streams down
from star-bright nights

yes
harmony resides
in the swoosh and twirl
of our love-hungry eyes

yet it is a false
stay of execution
between her thighs

where the last meal
of her dark almond eyes
presses back the winds of volatility

for you are still alone

though each caress
still presses back
the winds of volatility

and although all the reaching out
seems to be a flag of surrender
it doesn't matter

for who we are tends to get
splattered against the canvas
anyway

and what we have
is time's shifting hourglass
leaving choking imprints
around our necks

so let's lay waste
to the false equilibrium
that streams down
from every star-bright night

let's ride this heart-shackling beast
into the wild violet expanse
while gripping the reigns
with wind-scorched fingertips

we'll smother fear itself
with the gristle of our hate
which cuts carbon sharp
like the razor-hard eyes of orphans

7.
in the velvet distance
a sequence of yearnings
emerges from the zig-zagging bees
of frantic motion

wherever the green grenade of spring
explodes into bounty
is where we will be

kisses
planted in
weeping eyes

shall resuscitate
our flatlining humanity

for the mirrored burning
of stars and minds
continues to light
our way forward

and who we are tends to get
splattered against the canvas
anyway

and if you look
from far enough away
you see that each wildly meandering streak
eventually becomes reminiscent
of being perfectly at home

like the eyes of dolphins
captured in mid-air

like the eyes of dolphins
captured in mid-air

The Harvester's Gap (Sentience Cubed)

1.
staring dizzily upwards
I raised a hand head ward to calm
the intracranial pressure

the reflective alien cliffs
skip my eyes like stones
over its expansive walls
of black nanocarbon

yet
for all its
glossy strength

its hold on
the galactic crow
of swooping clockwork
called time is

like a mountain
that juts boldly
abandoning the planet's surface
for the higher echelons
of the staircase atmosphere

but
what projects
shall recede

for gravity is
the sorest loser
of them all

2.
we raised
the dome of technology

to frustrate
the dark bird's claws

for generations
we had succeeded

we stepped meticulously
in boots of neurochemical lucidity

extended lifespans

biomech
interconnectivity

we were
enmeshed

embedded in the
feral landscape of
quantum processors

but
in dwelling quietly
inside the sands of time

the threat
of the destabilization
surfaced

the harvester
returned on the
concentric wings
of the time-nuke

the seismic
activity spiked

the discontinuity
began

despite quixotically
implemented countermeasures

we lifted our chins
as the hammer blow struck

discontinuity time-nuke
the
harvester awoken
rips in time-space
black-scatter
nebula rising

albedo shift to
atmospheric night

a
million years
unrolled in
cryogenic fountains
of infrared light

so said
the solid cube:
/
]-*

we listened
and tasted the particle confusion
like insane martyrs
before we finally
short-circuited
en masse

3.
the quantum irregularity
left our tertiary components
leaning idly
against the cylindrical
chamber walls

and
in an ant's eye blink
the implants all became ghosts

never having
existed

our energy sacks
torn from the vats
of gel conductors

never having
existed

even
the miniature in curves
of rows of transparent micro-lanterns
flipped off

oxidizing into a
Rorschach epitaph
instantly

and
though the planet
remained

we had been unlaced
from the very
fab
sp ti ric
me ace of

VI. In The Shadow Of This Fluctuating Tree Of Awareness

Absence Is The Tenderest Whip

Oh, my
lavished one.

I am
so far
from comfort.

Lend me
your arms
to sleep in.

Swing Of The Heart

I.
The unutterable absence of it all.

Distance, an ache that is everywhere,
revealing: *you are not here.*

II.
Even as the firm ground dissolves
into a muddled reflection
of your heartbeat-arresting smile,
the nourishment in that familiar image
discreetly calms my starving eyes.

Your echoing goodbyes assail me
like yearning whispers in the dark,
murmuring about life's inconsistencies.

Yet still night is tender,
full of reprieve.

Regret Drinks Quietly From Her Own Image

A. simple heartbreak of no longer touching palms

as others with their glowingly undarkened hands
coil together in celebration
you recall the swift horses of
your astounding wounds:
the daring leaps taken before the fall
when the safety of intertwined hands
mistook you for a home

B. memory

the careening star-fall left you together,
yet alone against the black-drop depression of the sky
and seemed to survive even the rushing naiveté
of imploring, love-trembling eyes

C. reflection

cleared of liquid-fatigue by restorative lips
you slipped your smiles deep inside
the sleep-drink spices of winter

How A Shaft Of Light Can Be Worth More Than A Piece Of Jewelry

The slight silver bend of
the untarnished bracelet he once gave you
now flutters like the winged-edges of a Dove,
cutting a refreshing swath of nostalgia
through the formless contours
of your breezy memory.

You fall through the floor of your imagination,
harshly tumbling into the arms of odd comfort:
your vulnerable cave geology.

Oh how the sharply ratcheting pulse of
your perceptibly striated scars
reaches so deeply into
the constant slow crawl
of your recovering heart.

Downward, steadily downward,
you descend from the high cliffs of yearning.

Felt My Dry Skin Press Against The Screen Door

1.
Something in the muscles of my face
twitched the circular patterns of your eyes
into discs spinning thin strands of regret
around your shoes.

We stood quietly there
and drank open doors
in order to shut the ones that led
to our heart-pain centers.

Lifting the drifting heat lines into my eyes
the hill's light blew steadily across our faces
as you spun your constellation of goodbyes.

2.
How does a world unfurl?

Not obliviously like ink on a newspaper
but thoughtfully like a cat
stretching with enjoyment:
the tendons signifying an end
and a beginning
all at once.

So As Not To Disappear Entirely

I.
A circle
diminishes
to a fine point.

Over-rung
bell of sadness,
please continue on
without me.

II.
The pretend laughter
of befuddled earth-children
overpopulates the earth.

In the spinning dark
circles flutter like haywire satellites
echoing jumbled transmissions
between each blink
of my stinging eyelids.

III.
Here in the pastoral landscape
of my self-destructing mind
I search desperately for the
healing algorithms of love.

You Are A Weeping Tree, I Am Hollow With Regret

1.
If I could stop gravity
from tugging your bitter
sweetness ever downward
towards the earth's
molten metal core
I would.

The entire galaxy would suddenly grind to a pause
like a comet drowned in amber.

I would hang head first
over the motionless edges
of the time-break just to retrieve
and reunite the world-worn contours
of your now camouflaged face
with my mind.

In the inertia-less space
I would introduce your left eye
to the glorious symmetry of your right.

And the slight upward curve of your lips
(which appears only when joy rests
fruitfully upon your tongue):
deep inside the discontinuity I would harness
its tumultuous heart-bloom and send it
echoing forever into the yearning chambers
of my dense center.

2.
If this concrete-walled regret
was a dream I would quickly
wake to you.

Instead, your bleeding silhouette
sits in palest secrecy
near my empty hands
in the night.

As the freezing drumbeat of time
taps its steady rhythm against
the windows of my heart,
a slowly expanding circle of fog
obscures my entire universe,
turning all that we made together
into a deluge of indecipherable,
space-black tears.

Resurrecting The Mournful Dislocation Of An Emotional Crossroad

I.
The twisting spindles
of nature's Quenched Desire
poke angrily into her spine
with the fresh sharpness
of slaughtered promises.

The greasy aftermath smears love's lips
with a reverse alchemy
of throat-to-chest explosions
that transmute her golden heart
into jutting spires of leaden remembrance.

II.
All that glistens
in this guilty-eyed
nightbloom of regret
is the ghostly remnants
of his now-blackened gift
of Sky Flowers.

(Yearning and fulfillment
break like two glass brothers
smashing into the strength
of each other.)

III.
Initially the blooms swirled and swelled,
splashing the skies with the boldly-uprising buoyancy of spring,
but now they have fragmented in anguish,
fallen to the earth like lodestone tears.

(Crushing terror
of finding yourself
in bits and pieces:
not knowing
what goes where.)

Emptied Vessel, Stardust Goodbye

I.
Two unwilling eyes stare with trepidation
at the bewildering hollowness
of an empty human hand.

A fingertip memory exhumes
the drawn out movement
of five digits retracting,

retracting to the convoluted symphony
of muscle and tendon *electricity*.

II.
Like a feather descended into a river,
your float above the wandering undercurrents,
calmly melting away into grieving-hominid facial expressions.

The halted mirror of decay in your face
reminds of the heaviness of fruit
and the tiny, uniquely evolved lifeforms
that naturally converge to feed upon bruised,
punctured skin.

III.
Somehow in your blank stare,
the entire history of the universe is bundled up,
compressed and made sensual as a lover's lips:
as if each cushioned love-kiss received in life
was amassed into a solitary moment
then squashed sublimely against your diminishing lips.

Underneath, within the echo of time,
you must be belly-laughing
at how the stomach-ache sobbing
(and each serene and furtive glance of grief)
so ostentatiously projects the strength of the living!

From the soul-open stillness of your heart,
to the uncaring mask that has become your face,
the mismeasured hours of your life
seep grudgingly from your quieted bloodstream
to a mass of soft-painted goodbyes
that line your callused hands
like a protesting bouquet of flowers,
one petal lightly adorned
for each joyously savored ripple of time
that passed through your knowing lips.

Her Statue Had Brick-Red Hematite Streaks (Tendrils of Fe2O)

1.
Iron is life and death.

2.
We trace our striated veins like mineral lines,
blood full with iron, yet also bombarded with oxidation.

Life pricks like slivers hiding in skin softness,
breathes like a lamp's glow in darkness.

You and I, we burst forth with the slowness
of a falling mirror, full with the reflections of
each planet and star formed in the brooding silence of space.

3.
The glaciers you tried to carve with your tongue
all those years in the dark now come back twisted
and threadlike, spinning across light-seconds
of space in an invisible web,
grasping at everything which crosses its path.

Look, as your spindly creation spins itself into silence,
as millennia slip through aged hands.

4.
You were there, in the spaces,
breathing flesh into bone all the while.

You built the longevity treatments,
you carved them all with the erupting ganglia
of your transitory brain.

Turning inward your great web of wanting quietly
folded as each of your trillion fugacious blossoms
yielded complex patterns of lights which seemed
to be the simplest message: goodbye.

All your coal-web churches have cried themselves out,
filled their coffers with distance and the slowness
of light, brought a billion hearts tumbling into
the fraying edges of the universe.

5.

Beyond the cerebral hemispheres
responsible for posture, balance
and complex muscular movement
you drift into the seat of your uniqueness,
witnessing the spidery atoms
of our forever unfolding humanity.

6.

You created this magnificence from
the harsh expansion of black distance
and the tabula rasa of open space,
from the infinity of whispers
and touch-declarations of love
that moved suddenly from ears and lips
and eyes into the flickering center of power
blooming inside your head.

The polished flower statues you erected in her name
are strewn across ice-covered planets,
the hot winds below purple atmospheres,
and the utmost beauty and mutual gravitation
of binary stars.

The Lying Sycamore

I.
Its leafy fingers sway
and dull green shards
of staggered motion
peck at your body.

Laughter builds in each of their articulated stems,
laughter at the pointless growth
and regrowth you call your humanity.

What is there in the darkness
below the twisting Sycamore trees
but your frail ego
and millions of cells from your skin
sloughed off in stealthful fits
as you leaned this way and that
against the spotted tan of the peeling bark?

For once you were there:
lofty as the shadows,
high among the squirrel-dens and cicada-screams you stood,
then sat,
coralling beings into the cage of your imagination.

II.
All the while the garden plants,
with glacial patience,
steadily perked up by using the water
you had given them;

yet
neither they nor the flowers *knew*.

It was left to you,
since it even seemed doubtful that the scurrying mammals
could ask themselves a simple question such as:
why?

You drank the thickness of that trunk,
the vastness of its lie of permanence:
as it fed your fingertips and eyesight strength
the icy expanse of space continued to whittle away at your spine,
carving your hungry neurons into glaciers of imprisoned thought.

You, her, us all;
waged in our hopeless microcosmic battle against entropy,
we remain defiant.

III.
So I howl my defiance
as true love's consuming sensual palette
mutates all thought of these biodegradable hands
into a cushioning aura of rippling passion.

As she brushes away the physicality of forest and sky,
of planets and suns, of galaxies and coal-dark space,
my voice steadily rises towards oblivion like windstorm-strewn spider webs,
whose silky tendrils fail again and again at capturing the elusive rays of the
midday sun.

VII. Manufacturing Hope Amidst The Carnage Of Desolation

Iron-Red Canyon Of Our Unraveling Jubilation

1. First Impression

The rigid molecular structure
of her untrusting heart,
the infuriating geometry
of her aloof and wounded lips:

it seems time has built a shattered city
of gleefully jagged glass
to keep her soul-harmonics
erupting with the familiar
and steady cadence of ashen lava.

Yet the epiphany of her swift beauty
still smashes through me;
the undeniable warmth of her well guarded eyes
tells me that she may be the one
who holds the power to unbury my heart.

2. Unrequited

Violent-blue accents the swaying
and unrestrained heart branches
of longing.

3. Gathering Momentum

Ticking clock,
you dictator of the soul,
I press against your undefinable edges
just to feel the balm of her future smiles
swirling inside my cerebellum.

4. Rioting Against The Starlight

Bathing in this refined nectar of pooling ecstasy,
our love solidifies to the rhythm of bounding teardrops.

With ferocious acceptance we embrace
not only our obvious love-sharpened connections
(those boldly defiant spires of parallel affection)
but also all the imprecise silhouettes of gray:
those natural differences that inevitably
blur the edges of all heart-communication.

Any truth or untruth we must share
will be preserved in the lofty echo chambers
of our dueling heart-symphonies:

regardless of the contents
of our whispered vocalizations,
the panoramic landscape of your beauty unfurls
and I am harmoniously diminished,
a zygote swimming in the ether.

5. The Rising Scenery Of Our Forward Smiles

The slides of sorrow lay unused,
the dripping poison of discontent
is haphazardly buffered by our
gloriously improbable union.

6. Hope

Somehow,
in the tiniest crevice
of a mostly barren universe

just when you feel
that the world has been
permanently lodged into your throat:

suddenly
love will unfold itself
in front of your tearful eyes
like an artful magician;

the entangled fingers of love
will skillfully focus your attention
towards the elevated peaks
of joyously surpassed expectation,
again and again.

Though The Nectar Has Gone, She Still Tastes Like Flowers

I.
The flavor distortions inside my mouth
puddle on my lips in tiny lagoons
that fill with blues and purples.

This subtle autumn-is-over bruising
signals the upward ascent of love's defenses
(our drawbridges always rise
in defense of such weakened and
flailing love-connections).

II.
How does one distinguish
between our competing, retreating
essences while still wrapped inside
this love-tornado of disintegrating affection?

III.
Though our watery sphere has leapt across
an astounding stretch of empty space
since we last pressed against each other,
I still cry for her because
her jagged words make no sense
until dipped carefully into the flashing syrup
of her illuminating eyes and smile.

She is greased with poetry and starlight,
and just now someone has paused in thought,
tenderly recalling the faint smell-softness
of her thighs.

IV.
Why absolution teases us is beyond me.

I never pretended to be as agile and hollow
as the bones in the crow's burnt wings,
which both degrade and rebuild in perfect time,
yet as the universe recoils and begins again,
somewhere an astonishing and picturesque alien
will carve a flawless representation of her unique beauty
from a moon-sized chunk of stained glass,
and I want to thank him right now for that.

V.
Smashed into euphoria I whispered into her ears
though we didn't need to hear each other
in the deafness and beauty of unclothed love.

Our heart spaces echoed like an earth-sized room,
our emotions bounded off of the atmospheric ceiling
as love multiplied exponentially against
the undiluted strength of that look
she used to get in her eyes sometimes.

Brightness of boldly facing towards the same sun,
brilliance of being exhausted and complete
as I tumbled down her voluptuous heights
in a protective shell of certainty!

VI.
Ah, when all the universe is running thin
and stretched and bending
we will hold down two sides
of a magnificent line of quantum spider silk,
never to be separated.

Yes, Yes,
if there exists somewhere
the eight legs and
incredible design to return us to shape
before we burn out:
how we will bloom next to one another,
how we will bask in the trembling reignition of love!

With reunited hands,
let us peacefully ravage this unfathomable universe
into glorious submission, glorious submission.

Even In The Coldness Of Dawn, I Remain Viable

I.
Bittersweet despair,
my hands shake from the wicked instability
inherent in gravity-torn tears.

One drink from her once wound-calming chalice
now drowns the spiral staircase of my mind
with the gentle obstinance of steadily rising water.

This quicksilver brutality is chiseled from her harsh countenance,
raising exaggerated monuments of betrayal
from the cracked stones of epiphanies forgotten
and love songs rendered mute.

This devolving internal wasteland
of unvelvet moments engraves
a galaxy of mutated tenderness
into the base of my skull.

A kiss becomes a dagger of perception;
streaming light enters a darkened room
and what becomes lit up is the universal law that says:
everything must become undone,
before it can begin again.

II.
Once that timely kiss has sent you careening
and midnight skin has left you in a blissful fog,
you become your most vulnerable,
for it is there in the azure depths of wanting
that the universe sows its cruel seeds of change.

III.
Here in the heightening sky-burn of August
each pin-prick of life rises upwards like a curved blade,
glinting viciously against the tree-lined sunset.

IV.
Yet,
I shall feast again
on the transcendent joy of love.

The movements she will carve
with her gleefully swaying hips
will resurrect these eyes of gray.

V.
This thrashing river of emotion
floats all the dismay of the world
into my clenched fists where I then
unfold the crumpled ball of existence
with a taunting smile.

I am a full-bloom sun,
radiating into the warm
and blossoming sky.

VI.
Ah, to flux once more in the rising tide
of love's reawakening!

Once again we bulldoze the walls
of this universal orphanage,
reuniting our fists with the sky,
to beat the starlight back again,
to beat the starlight back again.

VIII. Moments & Mutations

A Purifier Emerges

Jittery bird-call hypnosis
pounces down
from the freshly greened trees.

Somehow, the erratic melody
of a hundred hollow, winged explorers
transforms instantly into segment
upon segment of surfacing worm.

Searching for a better passage,
born into the rising face of spring,
this essential organism
reveals in locomotive undulations
the ancient and familiar
earthworm whispers
of humble prowess
and circular regeneration.

Wet Eyelids Flicker As The Heart Returns

Wading into
the thrashing stream
I stopped to catch my balance
over rocks slippery with algae.

My heart was dried out like
an orange peel left in the sun
but not anymore.

Her currents have rescued
the sparkle from the pit of my stomach
and sent it hurling back to the tip of my eyes
for use on this buoyant June day,
for use on this buoyant June day.

We Reinvigorate Our Eyelids By Resurrecting The Soot Of Time

Drifting below the shrugging branches
in alternating bands of morning light,
a scattering of wavering leaves
is exhaled from the wind-brushed treetops.

As the leaves wander downward
a sudden flush of landing-pad blooms
explodes in majestic vivid color,
reaching outwards
like the pomegranate-stained
thumbs of children.

How we yearn
to inhabit such moments,
to resplendently paint murals of renewal
across our protective cocoons of imagination,
from which we will then emerge pupae-like,
ever awaiting a lover's welcoming smile.

A Blotted Mind Of Scattered Earth Tones Stretches Skyward

I.
Bounding down from the hilltop
a whirling flock of sleek ravens
gracefully needles past my wobbling irises,
intent on splashing into the shifting wall of electricity
that shields this spherical tower of faltering intellect.

Wherever I hide,
wherever I hide,
they burrow like a pack of moles
towards my thought-streaked skies.

Look how they splatter like locusts of ink
whenever struck by the frenetic lighthouse of my thought.

II.
Clawing open the back of my head
they escape in a hail of crimson and black
like licorice bursting from a shattered piñata.

I am broken,
left straitjacketed to the metabolism
of a five-thousand-year-old tree.

Just barely alive,
just barely alive,
a half-note left hanging high and dry
on the sparse cliffs of life.

III.
Yet,
as the soft flutter of time
refills my cheeks with roses again:

here underneath
the cloud-swollen sepia skies
I rebound.

IV.
I rebound,
nursing my exposed skull
with the familiar sound of birds.

Songs of attraction and warning
cascade from one pair of ears
to another and another,
building to a crescendo
as a newborn rainbow unleashes
an avalanche of glinting wingtips and eyes.

I raise a protective hand,
trying to visualize the bonds
that connect their little minds
to each other and to the wind.

I raise a protective hand,
a solitary witness to the solemn glide
of their knifing shadows as they spill
from the spider-meshed treetops.

V.
Look how they splatter
like locusts of ink
whenever struck
by the frenetic lighthouse
of my thought.

Yet
here underneath
the cloud-swollen sepia skies,

I rebound.

Nothing Can Stop Me From Writing These Words

a poem-to-be
arranges scattered letters
into meaning

a poem-to-be
ties up my cerebellum,
takes the reigns
from my brain
without even asking

a poem-to-be
plugs into the ether,
rides joyously over
the parallel tracks
of *emotional wellspring*
and *possibilities*

a poem-to-be
guides electricity
through my remote-controlled fingertips
and scribbles a declaration:
I am no longer a poem-to-be

The Cacti Defend Their Nourishing Bodies Like Overgrown Blowfish

1.
Art flourishes and its
slave is momentarily unbled.

Nothing calms the raging bloodstream
like creativity unleashed.

Even those that don't write, or paint,
or compose:

the density of the sky
must still haunt them.

2.
Making art is like falling asleep
in a quiet desert oasis.

As the sun steadily rinses
the earth's surface with radiance,

the beauty of a solitary
yellow cactus flower is revealed.

Skull-Fire, Heart-Memory

1.
A quantum string connects
the spine-crunch nothingness
of the one-billion-light-year void
to this space poet's heart-dance.

(Not even dark matter
dares interrupt the isolation

yet in theory
a particle *here*

can be influenced
across space and time

by an anti-particle *there.*)

2.
It is the summer
of our love.

Smoky tendrils of blissful awareness
lazily ascend this inner landscape
of silk and steel.

A flock of swallows
crosses in front of the distant sun;
I touch your face again.

Illustrate Your Muse With The Needle Of Your Verse

1.
on her arms
carve a delicate
bloodletting

each pinprick
a sandy glint
in her Martian landscape

canals of meaning fill
until finally the storm has left her streaking
like an iron sunrise

on her limbs
the word-tattoos dry
like calligraphy
on tree trunks

2.
she
so mysterious

a
work-of-art
in motion

a
crimson flower
stamped with the light of dawn

The Polarity Of Water

She stands silver-eyed,
crying starkly.

The drops of reclusive molecules
roll down steadily,
yet reluctantly,
like the last drops
off dawn flowers.

glancing up from her chores

the flowers sun-stretch then halt
as their blooming spring cascade
crumbles into temple bells

Heart Flux Concrete

I.
Flames jab upwards,
spiking our frames into the shadows.

I sense a similar,
but milder heat flowing
from your unclothed shoulder to mine,
injecting the fluttering darkness
with a palpable lightness.

Our lips toast
to the decline of sorrow
as the beauty of your form
rinses the aching from my unsteady hands.

II.
As the candles melted and solidified,
they signified the kind of permanence
that seemed impossible until the instant
I pressed against you that first night,
when heartbeat to heartbeat, I softly kissed you,
love pooling in your starkly beautiful eyes.

Seeing Sunspots

1.
In the blurry serenity of our post-coital joy
we find ourselves in the stormy complacence
of a cascading waterfall:
at once experiencing all stages of descent.

In being finished our bodies know
there is nothing worth knowing
that isn't played out endlessly,
body against body,
heart against heart.

2.
Spaces in between
the softness of
your thighs,
warmth of
the looking into
that I must endure,
burn of delicate raging,
whispers of stabbing delight:
once more I feel the gaze of your eyes.

the geology of disillusionment

1.
the star shine
still crushes me

there,
in the dying light of June,
hungry shadows of discontent
invaded our weary hearts

2.
strips of light,
clouds rushing by
the stark moon

3.
I was very sick then
and knew what would
never be touched

and the pale face
slipped into the pale hands

4.
it was raining

I remember
the last moments
when we kissed

it was

so slow and precise:
the careful brushing of ancient dirt
off of an emerging fossil

in a forest temple a young man meditates beside the body of a deceased colleague

a furrowed brow
holds steady

in the
shaded tiny stilt-house structure
with 5 steps up

and drooping yellow flowers
lay heavily on the first step

and
below that, empty sandals
await their owner's blood-warm return

the trees,
they cover much of the view with slim, oval leaves

and twenty squares of stone
outline the ground within the haphazard, wooden enclosure

to the left a house-attached blue bucket
floats, as if suspended in mid-air

where is the body,
with its gravitational aloofness
drawing us near?

who can hear this simple monk's extinguished laughter now?

from this Thailand grove,
with its full,
tornado-eye center,
his death-delayed thoughts
arc from master to apprentice
in a final, weighty lesson

(the boy sits with legs crossed,
placidly composed like the dead body
beside him)

Abundantly Mute Crinkle of Lighted Stars

I am a sinking love song,
heard through the wind
over stretching distances.

I am the bodies of children,
stacked like violins,
murmuring about the stolen breath
of strings.

Whole generations of tearful awakening
have drowned me in a swirling tide
of listlessness and unforgiving terror
at the thought of such ordinary suffering.

Exist, yet place your fingers into the earth
to see more than a point on this starving circle.

Remember when we were children
and our compassion for all life
had to be beaten out of us?

It is the injustice of roast beef
that keeps the slaughterhouse fences so high.

The Healing Beauty Of Unconventional Thought

I.
A political drone covets the power to sway,
regardless of right or wrong.

Yet it is you who must sing the song of your life.

When chance is wrestled to submission
by determination, that is *victory*.

II.
From atop the racing blue dot
a core perspective shift forces revelation:
ignore the status quo to survive.

Be wary of the hive-mind's
honey pot of destruction.

Seek awareness of the velocity of money
(whose stinging arrows roughly delineate
the modestly traveled trail of Reality).

When chance is wrestled to submission
by determination, that is *victory*.

III.
When the medicine man says you are sick
because you aren't taking enough pills,
nature laughs and silently alights
on the sturdy wings of evolutionary prowess:
spinning in flight the cocoon of your enlightenment,
the silver moment when you realize that each of us
must pave our own pathway to health.

Each day that you draw your primate nutrition
entirely from the fruits and starches of the earth,
you cleanse the byways of your veins and heart
with an ancient fuel that heals with the blossoming grace
of biological familiarity.

When chance is wrestled to submission
by determination, that is *human trajectory*.

A Sad Goodbye To A Richly Emotive Artist

I.
You closed the pages
of your books one by one
and sobbed at the music
and the words that sopped up your feelings
as you turned them into balladry,
erupting from the volcanic-ash
depths of your mind.

II.
The boot prints left trails in circles
and the deepest impressions were from the times
you leapt boldly skyward in fits of insolence:
as your body awoke upwards to music
you serenaded the immutable face of gravity
with the heart-melting melodies you clawed from time's grasp.

III.
As stars bled silent radiation from space
you tended the tortuous years with your blood:
the atmosphere thickened with intent of escape.

IV.
You tore the pages
of your books one by one
and stopped the music
so the words that sopped up your feelings
would viciously burst you into memories
as the deep-booted impressions eroded quickly
into blank statements of ashen defiance.

No Fingerprints Left After The Lightning Storm

1.
Strings of fragrant flowers once ran along
the steady bumps of her spine.

Each autumn harvest of fingertips soothed
the clumsy tripping sound of their hearts
into equilibrium.

2.
[Lightning.]

3.
Inside the decelerating motion of their bodies
a ferocious world-weariness built itself up
with bricks of broken promises
from their shared past.

They bled a sap-like grief from the thin flicker
of their moist eyelids as the marrow of autumn
failed to console their flesh-heavy scars
with repeated flashes of awakening light.

The Sun Visits Garnet Memories

The metamorphic rocks once crystallized in patient bits.
Even now, they hold stiff against the droop of time,
translating light into the red, brown, white and green
gemstones that hang resolutely against a worn mirror,
inertly bathing in the multiplication of light.

Globules of ancient candle wax
litter the scarred wood surface with reminders
of a hundred iris-tipped conflagrations and
the low-lit romance of encompassing fingers and eyes.

The inviting green of the bedroom wall still exists
despite the cluttered asteroid belt of indentions,
holes, and tape remnants that speak of time passed,
love gained and held, children and blood vessels
come and gone.

And somehow, in the disjointed scraps of abandonment
the quick-smile significance of a faded bedpost engraving
skull-stamps a semisolid silhouette into the room:
parallel lovers pour out swift-softness from their mouths,
triggering joy in even the tenderest crevice of human surfaces
and imprinting the mirrored gems with the prismatic light
of warmth rendered and fascination revealed.

A Dreamscape Shaped Like An Empty Heart

I.
Stuttering eyelids awake,
dry with sleep.

Echoes
of unconscious whispers
sear through you just fiercely enough
to disturb your waking arrival.

Imprints of
true love destruction
silence your rooted tongue-movement
with the threatening scorch
of razorblade-lipped words:

I
don't
love you
anymore...

In your sleep
you compose parched music
with the distinct notes
formed of your eye's memory.

And as if the nightmare
had dissolved the present by gunpoint,
then forced you to search the molten rubble
of a love-broken reality -
your disenchanted eyes now ache
with the skull-heavy memories
of a shuddering subconscious.

II.
Yet how could an ephemeral dream
ever drain the vibrant color
from your flawless scars
of rapturous love culmination?

The thundering soul-skin wakefulness
(that she tattoos into you with the humblest grace)
is *monumental*
and has always been the shelter
from which the tenderness of your heart has sprung.

The Fragile And Gorgeous Edges Of Human Consciousness

I.
Formed of Algebraic clay,
space-time terrified
the first physicists who
understood its implications.

Lorentz stepped back and froze,
only one step from the mighty quantum razor.

II.
Parse a single grain of its sharp truth
and immediately you find yourself
reaching below to feel
the anxiety-calming firmness
of toes sifting through beach sands,
of ears listening to ocean waves,
of skin, hesitantly accepting the warmth
of the sun's wayward photons.

III.
How can the landscape
of our visceral senses
accept the scientific reality
that even the blade of a knife
is composed of mostly empty space?

The sublime logistics of the horrifyingly small
fascinates as much as it cuts and bruises.

IV.
When Einstein wore a brave halo of exploration,
he brought time into a darkened room
to meet the lips of space-curvature.

Revealed in that kiss
was the oscillating frequency of light,
the formless shimmering of atoms
that signaled their refusal to bend
to the will of human visualization.

V.
What does it mean to press the fallible human mind
against something so intensely small?

VI.
Subatomic physics works
just as well when it is the past
that is unknowable.

When the future suddenly becomes
the pallette from which you draw your experience,
this is what it feels like to be an electron.

VII.
Past, present, and future universes
seem to exist simultaneously,
while humankind stands starkly,
comically bathed in our own tunnel vision.

VIII.
Born of the unification
of your present and former selves:
time resolves backwards.

A stunning pool of liquid silver
rises up from the healing cracks
of a reversing earthquake to form
a watery human silhouette
which dances in unison,
occasionally spilling out conscious fragments
that momentarily drift away,
then suddenly return.

Humpback Triangulation

I.
Like a fairytale giant taken hostage,
dozens of crab-pot ropes
hundreds of feet long
circle her enormous tail
and limbs like hideous tentacles.

Her blubber lies sliced open haphazardly,
as if set upon by a group of frenzied
but poorly equipped
whale hunters.

II.
stiff whale mouth floats,
cinched like a horse
underwater

flippers front and left
ooze blood,
tightness inescapable

barnacles, stowaways
from the chill Atlantic

watch each nylon-induced laceration,
some longer than the human body

blubber, red,
white-foam violence,
blubber, red
standstill slices

III.
Lucky Humpbacks
live to the age of 50,
but here, 50 tons
are brought to a tormented
and unintended standstill
by nylon technology.

IV.
the earth's gravity greedily hauls
the dozens of 90 lb crab traps downward...

blowhole gasping,
mammal genes push overdrive:

no
oxygen
here

but plenty
of oblivious
gravity

elevate, elevate
high enough
to survive

V.
The down-turned corners
of his sorrowful mouth
remember the routine motions
that drop crab pots
from his boat
into the coastal waters.

Thus his face is a sculpted stare,
as rescuers with trembling chins
dive into the waters
to cut ropes,
to stab at a slab of interspecies respect.

They fear being crushed
into insignificance both literally
and metaphorically,
yet what flattens them into wonder
is a mysterious and constant vibration
that might be her leviathan excitement
spilling over at the prospect of meeting
such helpful new friends.

VI.
wet suits

half-filled,
nervous bellies
pleading for
spatial awareness

groups of tiny fingers
bloodless knuckles
and knifes

minute after minute passes
beside mammoth
limbs and eyes

one mistake and:
clobbered,
unconscious,
swallowing the sea

but each instant
of survival stretches,
molds into a grandkid-pleasing
story of how you firmly held
a curved knife
to the throat
of a 50 ton whale

VII.
Cutting the line tangled in her mouth,
a diver's heart arcs suddenly outward
into the sea, where it melts away
in a fearful wave and then returns triumphantly
upon the wings of her enormous winking eye
which watches and measures his every motion.

As the severed ropes slither
one by one by one
into the drunken motion of descent
she realizes that freedom
is finally a flick of the tail away.

The massive burst of underwater circles
releases majestic gravity- and sea-defiant smiles
from underneath each swirling mouthpiece
and suddenly a tremendous mountain
of nuzzling gratitude invites miniscule hands
to pet a brimming shadow of restrained
and agile power.

VIII.
late February
in a boat

coral heads off
the Dominican coast

I swear it was her
spy-hopping

just to see
me again

eye to eye

IX. On The Craft

Crimson Manifesto

Here is where I crash this ship of anguish
against an island of words,

in the vain hope that each tender yearning
might be quelled by catharsis.

But no, look:
there against the hillside;

the brilliant ache of loneliness
blooms unobstructed,

its color a riot of hues
stolen from the blood of a poet.

The Lips Of Sacrifice, The Thorn Of Knowing

I.
We,
the inevitable
children of matter,
dance blindfolded across
time's unfathomable tightrope.

II.
Let us pool every blood-red drop of anguish
as we take pen in hand and begin to scribble
the instructions of our escape plan
into the bruised azure,
into the bruised azure.

III.
For we,
the inevitable
children of matter,
dance blindfolded across
time's unfathomable tightrope.

Fortifying The Boundaries Of A Enlightened Quantum Heart

I.
Look at the fierce word-wolves
that emerge from inside of us.

Behold the many nights passed,
spent stooped over the midnight altar,
silently weeping charcoal tears
into the deepening abyss
of artistic expression.

II.
We,
the word-hounded,
the skull-bound,
irresistibly driven to drink from rivers,
mountains, continents, atmospheres,
planets, star systems, black holes,
galaxies, galaxy clusters,
and the very structure
of space-time itself.

There,
straight-jacketed into the streaming void,
our eyes fill with quantum teardrops
as we dance our fingertips
defiantly across death's blade.

III.
Each hard fought poem
scars our aching hands
with black carbon streaks
that only make us stronger.

*Look at the fierce word-wolves
that emerge from inside of us.*

We carve their gemstone teeth
with the jagged ripples of abandonment
that flow from the steadily accelerating domain of space-time.

*Oh behold the many nights
spent stooped over the midnight altar,
silently weeping charcoal tears
into the deepening abyss
of artistic expression.*

May The Cottony, Puffed Chest Of The Winter Sparrow Pad My Eyes

I. From A Curious DNA Template These Words Are Etched

The echo of a single hominid heart refracting,
the leaping mirror tide of joy and sorrow retracting:
nature's unique bipedal creatures wonder why,
there amidst the night chirps and the hollowed-out darkness,
the universe must always eat her children.

II. Into The Fabric Of The Interstellar Mayhem

As we sit, resting our two legs and hands,
reposed on an insular dot that drifts towards infinity,
a questioning nest is woven from our collective threads
of astonishment and tears:
this is what binds every artist to the vicious black filaments
of the reaper's scissors, which clip, clip, clip
in a sloth-like crescendo that underscores
both the rhythmic beauty and raucous transience
of every thrashing heart.

III. Starkest Universe, Consider Yourself Warned

Like every gray streak observed by the keen-eyed owl at night,
these word-soldiers must scurry towards each receptive iris
to unlock the twin doors of safety that lay firmly rooted
on the gushing banks of human consciousness.

My words and images will flourish like heat in the candle's flame,
fed steadily by the resilience of every being, alien or human,
that has ever swallowed the pale geometry of space
and still kept moving forward in bold entropic defiance.

I will be the sun who swallows the black hole.
I will be the stars that refuse to shine.

Before I die
I will start a supernova
using only the tip of my pen.

A Molotov Cocktail Smashing Into The Windows Of Space-Time

1.
This universe will bleed you
into a fucking river.

It'll sever each limb of exploration
that emerges from your howling mind,
devouring skin and muscle and bone
before carelessly tossing the remaining gristle
into a writhing ocean of heartbreak.

Soon all that remains in your dessicated center
are emaciated clouds of numbness
that haunt your inner landscape
like the eyes of hungry children.

Yet,
there under the ghostly stare of night,
the forced march continues ever onward
as the throbbing rhythm of a laser-guided consciousness
refills your footsteps of yearning,
one sip of ancient starlight at a time.

2.
*This universe will bleed you
into a fucking river.*

*It'll sever each limb of exploration
that emerges from your howling mind,
devouring skin and muscle and bone
before carelessly tossing the remaining gristle
into a writhing ocean of heartbreak.*

So we fight back with words
drenched in pathos,
the poet's gasoline:
with a plaintive cry each
carefully-crafted message
is thrust into the deepest corners of darkest night,
into the deepest corners of darkest night.

3.
Even if I forget everything;
I forgive nothing.

I breathe the tears
into these words
to give them life.

This is a pure poem,
one that you cannot touch.

It is a sacrifice for myself.
It is mine and mine alone.

It is me,
huddled here in the dark,
lighting the cloth with the fiery flames
of my festering discontent,
hurling this pathetic token of revenge
into the darkened skylight,
into the darkened skylight
with a solitary thought flickering across
the stained glass of my mind:
burn you son-of-a-bitch, burn.

CPSIA information can be obtained at www.ICGtesting.com
Printed in the USA
LVOW050144200112
264727LV00004B/199/P